IMAGES
of America

# FRANCONIA
## AND
# SUGAR HILL

This remarkable hooked rug measuring 55 by 104 inches is the creation of Esther Tefft Serafini, who was aided in the work by various members of her family over a period of some ten years in the 1950s–60s. The designs were traced on the burlap backing by her husband, Enzo; the wool came from the sweaters of three generations of the family! Individual batches of the wool were then dyed the desired color before being worked into the pattern. The treasured heirloom hangs in the small front parlor of the Homestead Inn in Sugar Hill.

IMAGES
*of America*

# FRANCONIA
## AND
# SUGAR HILL

Arthur F. March Jr.

ARCADIA
PUBLISHING

Published by Arcadia Publishing
Charleston, South Carolina

Printed in the United States of America

Library of Congress Catalog Card Number: 2008941580

For all general information contact Arcadia Publishing at:
Telephone 843-853-2070
Fax 843-853-0044
E-mail sales@arcadiapublishing.com
For customer service and orders:
Toll-Free 1-888-313-2665

Visit us on the Internet at www.arcadiapublishing.com

*To Pauline Lee Hannah*
*with unbounded admiration for her indomitable spirit.*

# Contents

# Acknowledgments

The primary sources of photographs used in this work have been the Sugar Hill Historical Museum, the Franconia Area Heritage Council, and the Littleton Historical Museum. In addition to giving me complete access to their photographs, Jane Vincent, curator of the SHHM, and Jewel Friedman of the FAHC have been unfailingly generous in giving help and supplying information. Jane, in addition, has earned my undying admiration for braving the unheated interior of their "vaults" to drag out boxes of photographs in mid-winter.

In addition to these major sources, the following people have provided material from their private collections that has added immensely to the interest and value of the undertaking: Sharon and Anthony Avrutine; Jim Cantlon; Marion and Norman Gilbert; Joan Hannah; George Herbert; Barbara Hill; Gail Lehouillier (Cannon Mountain Headquarters Office); Mary Helen Lovett; Ray Martin; Barbara Serafini; and Charles Stewart.

The words to go with the pictures have come from sources far too numerous to list in a work of this kind, but I feel I cannot omit mention of a few publications and a word of thanks to some of the individuals who have made it all possible. Much information on the early period has been gleaned from Sarah N. Welch's *History of Franconia* and from Phyllis Bond Herbert's *Early History of Franconia, NH*; for more specific data on Sugar Hill, *Lisbon's Ten Score years, 1763—1963* by Hazel Ash Pickwick was very helpful, as was *Sugar Hill—A Glimpse Into the Past*, edited by a committee from the Sugar Hill Improvement Association.

Among the individuals who have provided special information I wish to thank the following in addition to the above: Norwood Ball, Robert Ball, Anita Craven, Edgar and Virginia Davis, Don Eastman, Jennifer Peabody Gaudette, Marion and Norman Gilbert, Ruby Gray, and Jere Peabody. A very special word of appreciation goes to Dr. Harry McDade for his research on the medicinal properties of spruce oil, a subject on which information is not readily available. And finally, it is a special pleasure to thank the helpful people at the Littleton Public Library, Kathryn Taylor, librarian, and her able assistants Ellen Morrow and Steffaney Highland, who took much of the pain out of the chores of research with their cheerful good nature. Amy Bahr, librarian at the Abbie Greenleaf Library in Franconia, and her assistants were equally helpful and have my thanks.

To my wife, Jacqueline, my admiration for never-ending patience and thanks for helping with the seemingly endless details.

—A.F.M.

# Introduction

The closing years of the eighteenth century were a time of great significance throughout the Western World. James Watt's 1780 perfection of the steam engine, the first prime mover since the harnessing of wind and water, ushered in the Industrial Revolution. Revolutions of a different kind were taking place on the continent of America and shortly after in France. In 1783, the year the American Revolution ended with the Treaty of Paris, the Montgolfier brothers' hot air balloon carried two men (not the brothers) into the atmosphere, making them the first humans to leave the surface of the earth successfully.

The thirteen anything-but-united states (colonies) were in turmoil, and it appeared for a while that they might only have escaped the frying pan to land in the fire. Differences over money and trade were so great that war was threatened by one state on another on more than one occasion. The men who had fought in the Revolution remained largely unpaid and extremely disgruntled.

The new country that had just won the right to govern itself found this far from an easy task. The nation consisted of a narrow strip along the eastern seaboard of the North American continent extending roughly from what is now Maine to Georgia. Canada, according to the treaty, was awarded the Great Lakes and land south to the Ohio River. Territory west of this to the Pacific and including the southeast finger of the continent all went to Spain, including the mouth of the great Mississippi River. In between the Father of Waters and the Appalachian Chain was "Indian Territory." Under such circumstances, it is a miracle that the Constitution and Bill of Rights that would create one of the greatest nations the world has yet seen were adopted in Philadelphia on the Fourth of July in 1788. The concept of "one nation, indivisible, with liberty and justice for all" became a working reality and although severely tested it has lasted over two centuries and does not appear about to fail. What had started as a commercial venture on the part of several European countries began to develop in unexpected directions.

Against this backdrop is set this picture-story of two tiny communities hewn out of the wildness of the New Hampshire forests and mountains and the people who, looking to better themselves and their families, ventured into this undeveloped land and quite literally "by the sweat of their brows" not only survived but in due course prospered. What inspired them to this effort? In those days of minimal communication, what could the Schoffs, Aldriches, Bowleses, Beans, Herberts, and Smiths have known of the ferment of ideas that was stirring on both sides of the Atlantic? It is difficult to believe that they knew they were taking part in a "Noble Experiment," but we can and must believe they were motivated by genuinely good principles; that they were in the main honest, certainly hardworking, moral people who believed they could help themselves without injuring others.

So they came: men, women, and children from the fringes of the older (a century and a half by this time) settlements. They hewed the trees and delved in the soil; they spun and weaved; planted their corn; husbanded their livestock; nurtured their children—gave us our lives and our country.

# The Pathway

By the 1760s the route up the Connecticut and Ammonoosuc Rivers was pretty well established; Gunthwaite (Lisbon) had a few dwellings and a stockade for protection against Indians in this advanced outpost; the Nathan Caswell family had gone further up the Ammonoosuc and laid out a claim in what would become Littleton. In 1780 William Aldrich traveled this route by ox-cart and after stopping briefly at Gunthwaite, pushed on, probably following the brook now known as Salmon Hole to the farthest corner of the grant, the area we now call Sugar Hill. He did not remain, perhaps discouraged by the death of his son Peter and the loss of their cow, the story goes, which was killed by a bear. But another son, Moses, "came, saw, and conquered," becoming the first permanent settler on Sugar Hill and the founder of a family whose descendants remain there today.

The settlement of Franconia remains more of a mystery, but we do know that Jacob Schoff, one of a group who were brought from the duchy of Franconia in old Germany, was an early explorer of the region and it seems likely that these people are responsible for the name. It seems probable their route to the region was up the Ammonoosuc as far as a tributary from the east (now Gale River) and up this stream to the pleasant valley just north of the mountain range since that time also known as "Franconia."

# Photographers

Wherever possible, the photographers, particularly those who worked in the nineteenth century, have been identified by letters in parentheses following the caption. A "?" after the initials means that the identification is probable but not definite. The letter codes are listed here alphabetically by first letter:

(AWJ)—Arthur W. Judd
(BFN)—Bessie F. Nickerson, Sugar Hill Studio
(BWK)—Benjamin W. Kilburn
(CLP)—Claude L. Powers
(CPH)—C.P. Hubbard
(DHP)—Dick Hamilton Photos
(DR)—David Rhinelander

(GR)—Reverend Guy Roberts
(JE)—Julia Eaton
(KB)—Kilburn Bros.
(KPS)—Kitchen's Photo Studio
(LN)—Lafayette Photo
(ONA)—O.N. Aldrich
(SSN)—Reverend S.S. Nickerson

# One

# The First Hundred Years

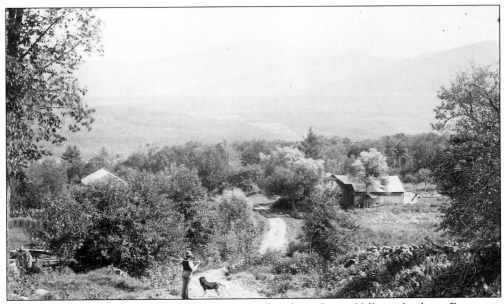

This early scene looking across the Easton Valley from Sugar Hill to the hazy Franconia mountains is a far cry from the scene that greeted the early settlers who could see little but the huge trees of the forest. The buildings, the cleared fields, and the stone walls are surely good reasons for satisfied contemplation by the farmer and his dog. (MTN)

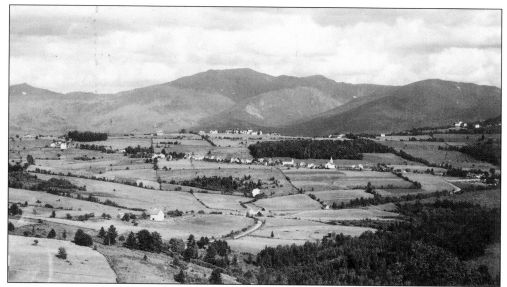

Even more startling to the modern eye is this view of Sugar Hill at about the peak of its cleared-fields era. In addition to the village street (in the middle foreground and beyond), the magnificent mountain backdrop and the hotel complexes on Sunset Hill can be seen.

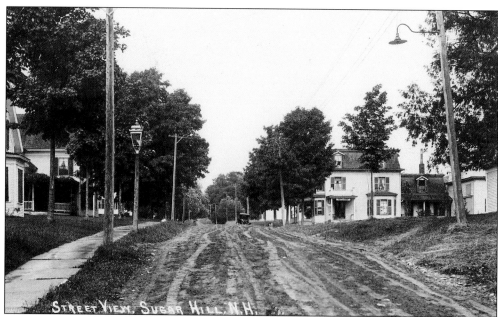

Sugar Hill Street (please don't call it Main Street even if it is) is seen here before the days of paved roads. Several of the buildings look much the same today, and others were destroyed by fire. Of special interest are the two street lamps: kerosene on the left, newfangled electric on the right.

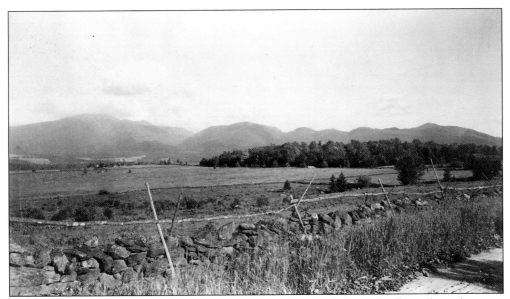

Another fine panorama of the Franconia Range from Sugar Hill shows the flat valley in between and a field to delight the eye of a farmer, especially if he wasn't the one who pulled out all those rocks and built the wall. (CPH)

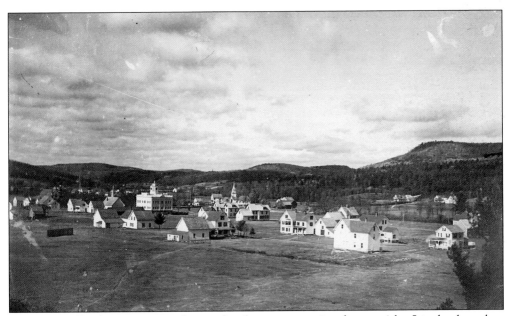

This unusually sharp image is the result of a contact print from a 4-by-5-inch glass-plate negative. It provides a view from Fox Hill looking northwest over the Village of Franconia in the early 1900s. (LN)

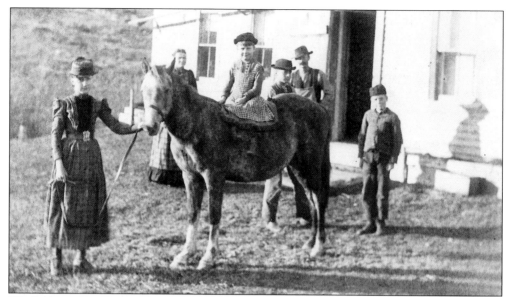

While there are of course no photographs of the first half of this period, this touching family scene reminds us that the business of the pioneer families was to provide themselves with food, shelter, and clothing, all to be derived from the land and their own labor. These are members of one of the Bowles families (more in chapter five). From left to right are Elgie, Mrs. Bowles (background), Clara, Ernest, Mr. Erwin Bowles, and Jay. The horse (unnamed) is no doubt enjoying this brief respite from labor.

Horses were not only essential work animals but were, save for shank's mare, the only means of transport. Before roads were hewed out of the wilderness they were ridden; with roadways came wheeled vehicles such as that of the Arthur Bickford family of Sugar Hill. (SSN)

Early settlers of the Franconia region quite naturally selected the flat lands along what is now known as the Ham Branch of the Gale River in the Easton Valley for their farms and homes. Such a one is the Brooks Farm pictured here much later in 1887. This is said to be where Luke Brooks lived at the time he is credited with the discovery of the Great Stone Face (1805).

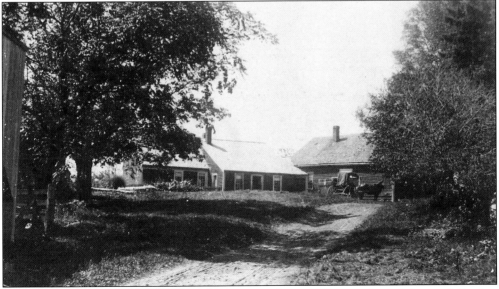

Another such early homestead, but this one on Sugar Hill, was that of Leonard Bowles. Members of this family came early to the region, stayed long, and made a lasting mark on the community.

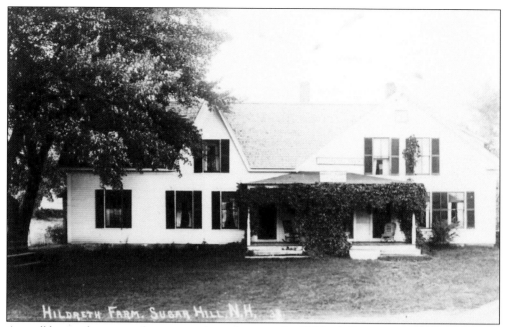

A small house that was to have a very large future is the Hildreth Farm pictured above. Late in the nineteenth century, two descendants of pioneer settler Jonathan Hildreth, who had built a log cabin in the vicinity a century before, began selling maple sugar cakes to summer guests at nearby Goodnow House. The daughter of one of these descendants married Wilfrid Dexter, who entered the growing business thereafter named Hildex. Today, descendants of the same family carry on a phenomenally successful restaurant in this building, which features pancakes with, of course, Sugar Hill's maple syrup. The descendants still sell maple sugar cakes.

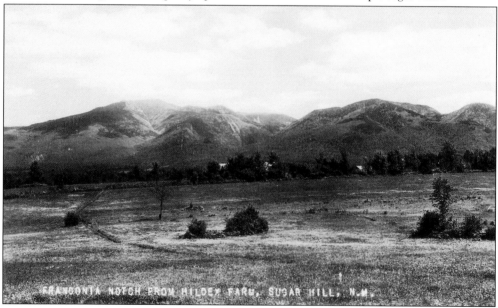

Here we have part of the amazing panorama seen from Hildex (now Polly's Pancake Parlor). If this photograph extended far enough to the left, the entire Presidential Range would be added to the Franconia Mountains seen here.

14

A pleasant farm scene on Peckett's Hill looks down on Franconia Village, all of which is obscured except the Forest Hills Hotel in the far distance at the upper right. The low light suggests that the photograph was taken in the late afternoon.

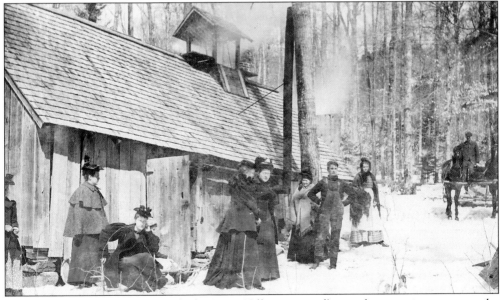

The sugar maple (for which no doubt Sugar Hill was named) was almost as important to the early settlers as the apple tree: both provided a necessary, healthful, and much appreciated food. White sugar was hard to come by but maple syrup and sugar made good substitutes. The sugar camp pictured was on Lovers Lane in Sugar Hill. It was operated by the Bowles family, some of whom are shown here with friends. From left to right are Kate Bowles Palmer; Anna Nickerson; Elgie Bowles; Bessie, Julia, and Sarah Nickerson; and Ernest, Vienna, and Erwin Bowles (with the team bringing in the sap). (SSN?)

15

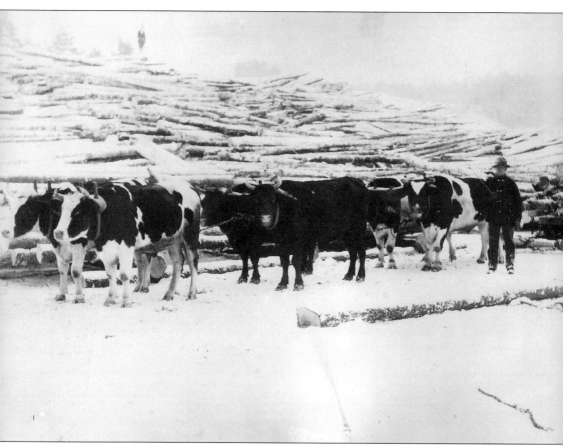

Wood was one of the great natural resources of the North Country and in the early years it seems that just about everything was made of this incredibly versatile substance. Not only did it serve as the prime structural material for dwellings, barns, bridges, mills, and their working parts, but most farm implements and carpenter tools were made of wood with a bit of precious iron for a cutting edge. Even plows were all wood until metal blades became available and for a much longer period harrows had teeth made of oak or hickory pegs. Such pegs were also used to fasten together framing timbers, and thus the name "tree-nails" (trunnels) was created. And, of course, wood was the settler's only source of heat. So the cutting of trees was the essential first step for the pioneer dwellers in this region and before long it grew to a major industry. The demand for wood seemed insatiable and "logging" almost synonymous with "north woods."

The above image at least suggests the immensity the operation achieved by early in the twentieth century: shown here is a log pile of the Parker-Young Co. in Lisbon (at one time the largest manufacturer of piano sounding boards in the world) and the six-ox team that hauled loads of 50-foot logs out of the woods to the sawmill. Oxen were used because they were stronger, if slower, than horses and also less nervous (it's hard to upset an ox).

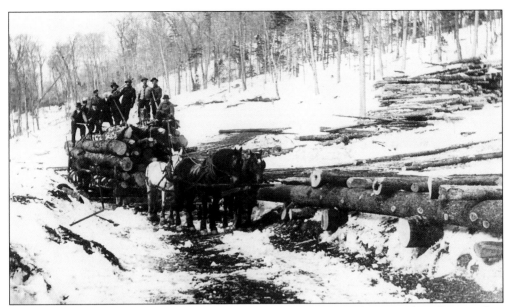

Horses were not, however, ousted from this form of employment by the ox. Perhaps because they were easier to handle, or because mankind just has a greater affinity for them, horses were an integral part of the logging scene. Trees were felled with cross-cut saws and double-bitted axes kept sharp enough, according to legend, to shave with. The tremendous logs were maneuvered by means of peaveys or cant-hooks seen here in the hands of several of the men atop the pile on the logging sled. The peavey is better seen in the picture below.

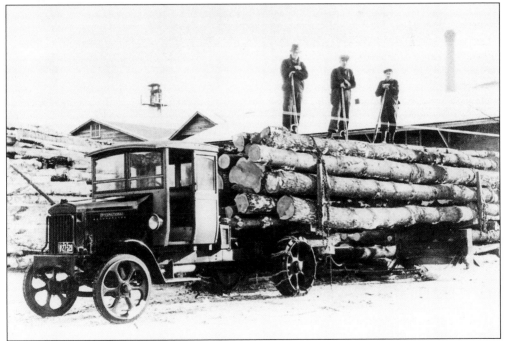

Soon after 1900, oxen and horses were supplanted at least to a degree by the motor truck like the International pictured. However, even equipped with chains, these could not replace the horse hauling the logs out of the deep woods, as they required something resembling a roadway.

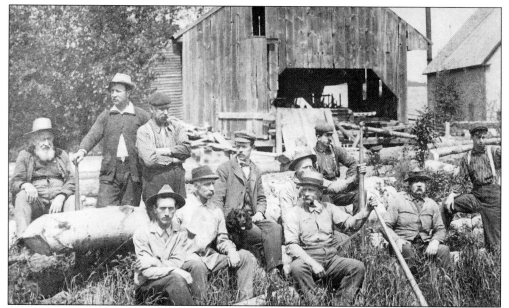

Early mills used "up-and-down" or "sash" saws (a mechanical adaptation of the pit-saw), but even with three blades in a single frame it was a relatively slow process. The circular saw with its rapidly whirling teeth revolutionized the lumber business.

The Brooks-Whitney Sawmill in Franconia was located about where the post office stands today. It was operated by waterpower, possibly from the same pond created by the Franconia Iron Works many years before. Other power sources were used later. Unfortunately, the workers in this image have not been identified. However, the man with the dog may be Frank Locke.

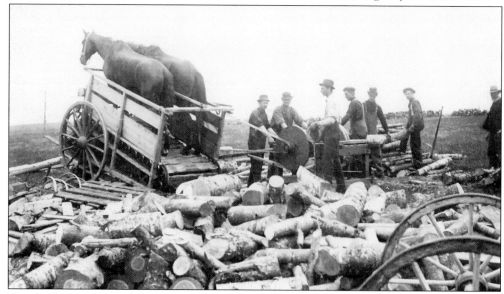

Treadmill saws operated by horsepower were mobile, which at least gave the horse a chance to get off the treadmill and see the country. The saws were used for cutting firewood, of which unbelievably vast quantities were used. Lucy Crawford, in her *History of the White Mountains*, speaks of their using a cord of wood in twenty-four hours. No wonder the treadmill saw was a welcome device. The Reverend Nickerson (at the far right) watches his woodpile grow.

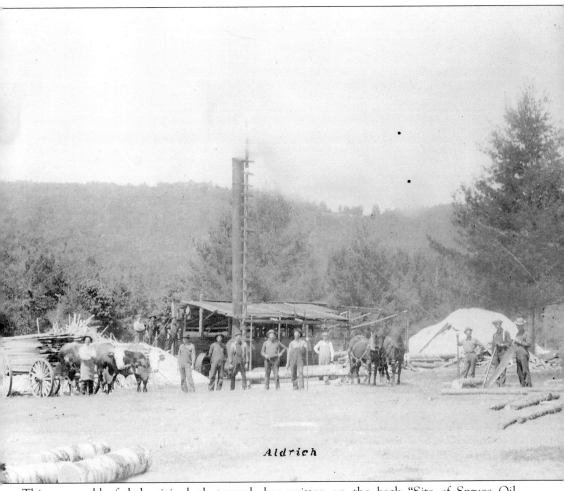

Aldrich

This regrettably faded original photograph has written on the back "Site of Spruce Oil Still Ext[ension] of Wells Rd. to the Coppermines" and has been the cause of considerable speculation and interest. The needles of the black spruce—*picea mariana*—are now known to be a rich source of ascorbic acid (Vitamin C), but the American Indians knew something else: a brew made from them appeared to cure scurvy, a disease with which they were occasionally afflicted and which was common among the French explorers in the sixteenth century who arrived in the Newfoundland region after months at sea with no fresh food. More than a few of the explorers owed their lives to this Indian medicine. So much for the distant past. That spruce oil was made in this region in the last century by a crude process of distillation seems beyond a doubt, even if it is beyond the memory of the oldest inhabitant. The building pictured is certainly a sawmill but it is possible spruce oil could also have been made there as branches of that tree would have been in plentiful supply. Moreover, there is a written record, source unknown, which describes the process (see next page).

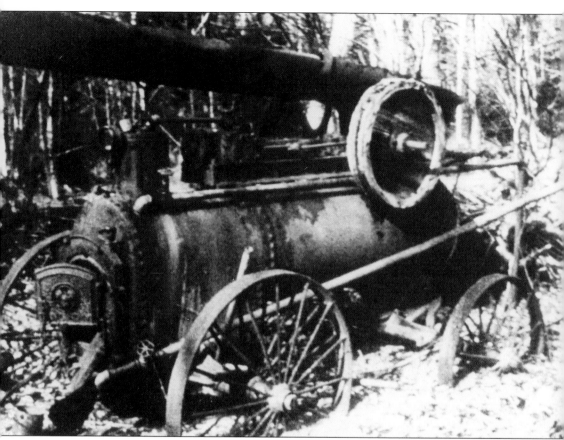

Fortunately, as the machine has since been scrapped, an enterprising local historiographer took this photograph a few years ago of an ancient steam engine with collapsible stack (so it could be moved from site to site). Such devices were used as power sources for mills but our interest in this one is that steam from it was used to make spruce oil as follows: young spruce boughs, thick with needles, were packed into a large wooden tub or silo some 4 feet in diameter; steam from the boiler of the engine was forced through the mass of needles and allowed to escape through a vent pipe immersed in a trough of cold running water—a crude but effective still! The steam containing the volatile oil was condensed and dripped out of the pipe as "spruce oil." It took twenty-four hours to process a load of needles. There is evidence that two such stills existed in the Franconia-Sugar Hill area.

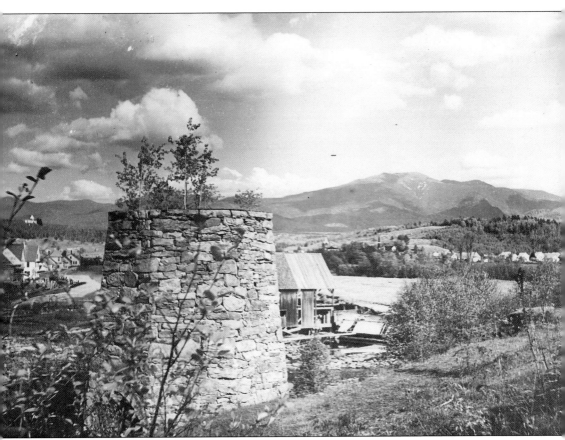

The origin of the art of making metallic iron from various ores found in the earth's crust is lost in pre-history. It evolved among many peoples in widely scattered corners of the earth and the lore was passed down through the generations until nineteenth-century science made it into a highly developed technology of immeasurable importance. "Iron" was the name given a new age in the development of mankind.

Iron was one of the things England wanted from her colonies in the New World. Bog iron and various ores were searched for everywhere. A smelter was constructed in Jamestown but failed to produce useful results. The Saugus Iron Works in Massachusetts was producing reasonably good metal from bog iron only some twenty years after the Pilgrims set foot on Plymouth Rock, and even the small inland village of Concord had an operating smelter and forge as early as 1666.

Who discovered a rich vein of iron ore (magnetite, $Fe_3O_4$) on Sugar Hill and when he did so remains a mystery, but it seems likely it was before Governor Benning Wentworth issued the grant bearing the name Franconia in 1764. At any rate, by 1800 mining and smelting were in process, no mean achievement for an isolated mountain community barely beyond its pioneer period.

An iron works even at its simplest is a complex thing requiring experienced and skilled workers and it is not our purpose here to describe it. Ours only to look at some of the few images remaining to us and pause briefly in awe and admiration of what was accomplished.

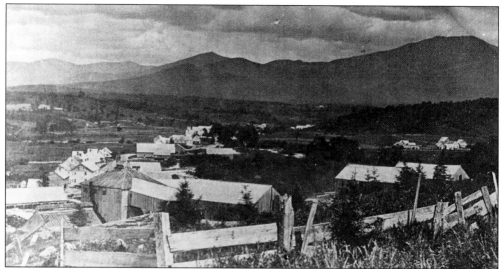

In 1910, Carl H. Richardson wrote the following about this 1868 photograph: "The large buildings in the immediate foreground are those of the old Iron Works. At the left and below is a sawmill shed over and behind which is the old (Iron) Tavern. . . . The large building to the right of these buildings at the farther end is one of the startch [*sic*] factories. Right over this is School House Dist. No. 1, to the right of which is the village church where union services were held. A group of buildings in the background is another startch mill. . . . Mr. Howland occupied those [houses] on the left, his farm being all the land about, on which land is now Dow Academy and its cottages and many residences."

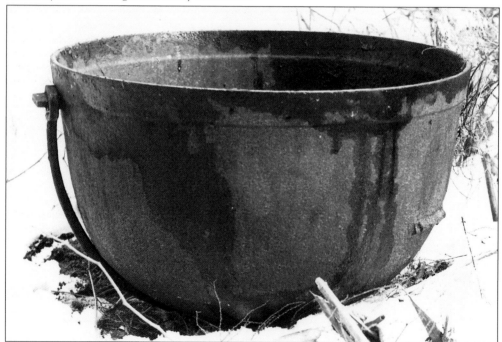

This huge kettle measuring some 3 feet in diameter is one of the hundreds of different items manufactured at the Franconia Iron Works. It was probably used for sap boiling, but like so many of its ilk came later to be employed as a planter, this particular one at Peckett's.

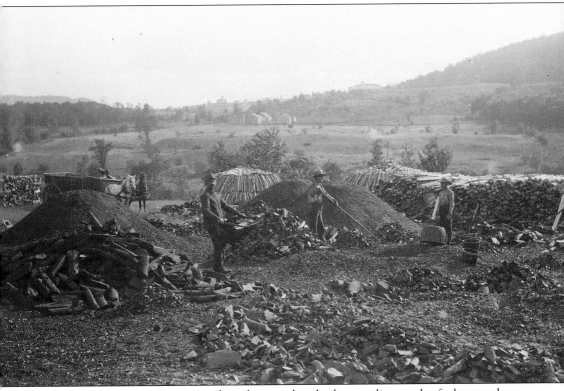

The smelting of iron requires two other elements beside the ore: lime and a fuel to produce the high temperatures required, which in early times was commonly wood charcoal. The three materials were dumped into the stone furnace via a loading bridge (the photograph on p. 22 shows the bridge; the stone furnace is inside the building). The fire was started and blown to a white heat by huge, water-powered pumps, the whole business not unlike the forge of a giant blacksmith. The iron was melted from the ore and ran out at the bottom of the furnace onto beds of sand where it cooled and hardened into "pigs."

The amount of charcoal required was enormous; a furnace such as this consumed two to three hundred thousand bushels a year so the charcoal burners pictured above were a vital link in the process. We still have "Coal Hill" to remind us. (MTN)

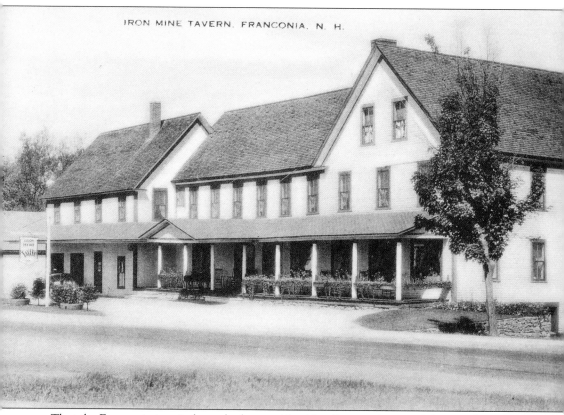

That the Franconia iron industry had a considerable effect on the town's history during its first half-century cannot be doubted. What had started as a tiny mountain hamlet with an agrarian economy was suddenly a mining community with not one but two foundry centers where ore was smelted, iron produced in several forms, and a wide variety of iron articles manufactured. The community seemed well on its way to becoming an industrial center, but that was not to be. In a little more than a matter of fifty years the property was sold at auction, and the sale included 4,500 acres of land, a blast furnace, forge, machine shop, blacksmith shop, wood and paint shop, mill pond, nine dwelling houses, a store, and other buildings. In 1884 fire destroyed all the buildings, leaving only the stone stack much as we see it today (see p. 21).

As mysterious as this all sounds, it was a pattern that was repeated by most of the small ironworks up and down the eastern seaboard. Ore or fuel supplies ran low; transportation to large population centers was difficult and expensive; and new equipment and techniques made the small operation uneconomical (the early investors were no less interested in a profit than today's). And finally, the discovery of tremendous deposits of ore and anthracite coal (which by then had replaced charcoal) in other parts of the country, also played a part. The dollar had spoken and Franconia was to head in a new direction. Ore Hill would begin to heal and for that some of us at least can be very grateful. (PC)

Religion played an important part in the lives of most nineteenth-century Americans. It was an evangelical age; people accepted a new kind of individual freedom with responsibility. It was also a time of social ferment (aren't all times?) and heightened moral awareness: temperance, female suffrage, and the abolition of slavery were topics of universal discussion and endless sermons, sermons which quite usually lasted two or three hours.

In all this the churches played a central role and sprang up in all communities as rapidly as they grew large enough to erect the buildings and support a minister. Ministers shared churches, traveling to several communities on a single Sunday, and for remuneration they were more likely to receive firewood and garden produce than cash.

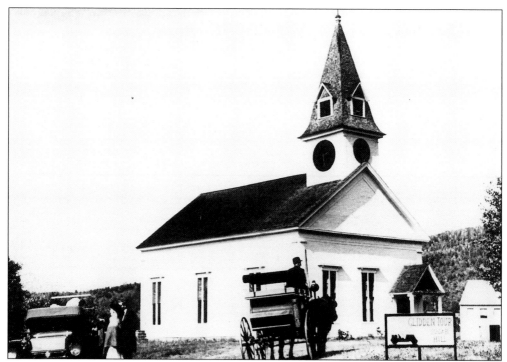

The first church building in Sugar Hill was the Advent Church, which was dedicated in 1831 and stands today on the same spot looking much the same on the outside. It serves now as an all-purpose community center known simply as the Meeting House and includes the town offices. The horse-drawn and horseless carriages suggest the early twentieth century. The sign announces one of the famous Glidden Tours of antique cars.

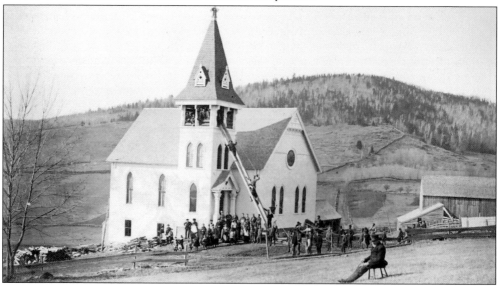

In 1885 the Baptist congregation, who had shared the earlier church with the Adventists, erected their own building on the corner of Lovers Lane and the main street. It has been kept in excellent repair and is still a flourishing church. Mr. Ben Bowles, seated in foreground, watches the raising of the bell he has donated.

26

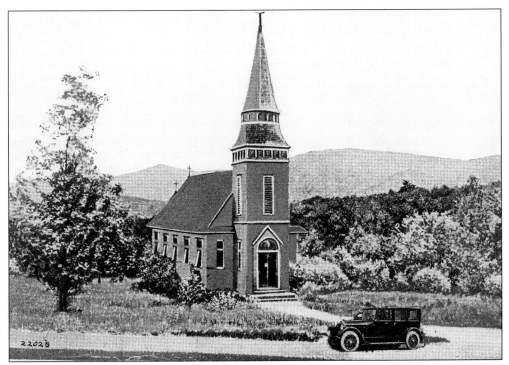

An unusually attractive, if tiny, church in a mountain setting of considerable beauty is St. Matthew's Episcopal in Sugar Hill. Built originally with funds donated by regular guests of the nearby hotels and well-to-do summer residents, it stands in the same scenic spot today, the entire setting surprisingly unchanged. Artists and photographers love it! (PC)

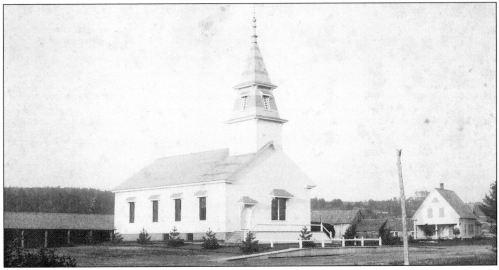

Franconia erected its first church building in 1832. Built and shared by Baptists and Congregationalists, it was first called the Union Church. The facility became exclusively Baptist in 1884. In 1947 it was purchased by the Catholic Diocese and moved to its present location to become Our Lady of the Snows. The original site on the opposite corner bears a bronze-stone marker. (Note the ubiquitous Forest Hills Hotel between the pole and peak of small house.) (BFN)

"Fire!" was a cry that struck terror into every heart in the days of wooden houses, wood-fires for heating and cooking, and usually no way to put out a blaze beyond a bucket or two of water. Other hazards were of course the open fires used in the blacksmith's forge and other manufacturing processes, as well as spontaneous combustion of hay and manure piles and the ever-dreaded summer lightning strike on a hay-filled barn. And if all this were not enough, when the railroads came the old wood-burning engines emitted showers of sparks that started more than a few grass and forest fires.

Such a disaster came to Sugar Hill, as it did sooner or later to almost all communities (even the top of Mount Washington!), on the night of May 30, 1893. Here is the story as told in the words of the Reverend Samuel S. Nickerson:

"Sugar Hill, NH 9 am May 31 1893

Sugar Hill Village was about half burned last night—twelve dwelling houses and one store. Fourteen families burned out. But a small portion of household goods saved. No serious accidents to anyone known but quite a number of narrow escapes.

The fire began in Mr. Palmer's repair shop and moved up the street as if the buildings were a brush heap until eight dwellings were consumed. It then returned on the opposite side of the street nearly to its starting point, burning four more dwellings. For a time it was thought Mr. C. Parker's was saved but small whirls of sparks set the barn on fire.

Those burned out in the order of the fire are Wm. T. Palmer, Silas Wells, Joseph Moody, Thomas Cox, James Eaton, John Pickering, Silas Howland, Lindsey Aldrich, J. Bowles (store), Chas. Streeter & Mrs. O.H. Young, Jackson Dustin, David Oakes, Hosea Howland, Chandler Parker.

The alarm was given about 11 o'clock and got under control about three am. Estimated loss—twenty five thousand." (SSN)

The work of the blacksmith was essential as soon as the settlers had got beyond the "all-wood" stage of existence and iron became available. He was surely among the first to set up shop to perform services for others. He turned his hand to just about everything that was or could be made of iron: shod the horses and oxen, and made and repaired the farm and logging equipment and the metal parts of carpentry tools. This unidentified smith must serve as our prototype of this useful class of worker.

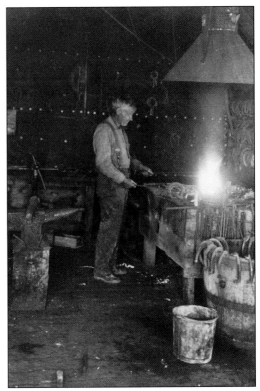

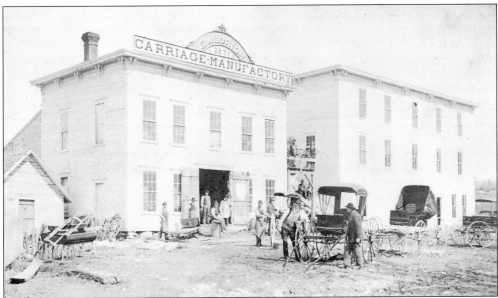

The crude sledges and stone boats used by the early settlers to haul rocks, timber, and farm produce gave way to the wheeled vehicle rapidly. No doubt wheels were often obtained from more developed centers and the wagon built by the farmer. But the time soon came when the demand for goods and services made it practical for individuals and groups to perform specialized services. The blacksmith was an early example and this carriage works in Franconia a much more developed one. (BWK)

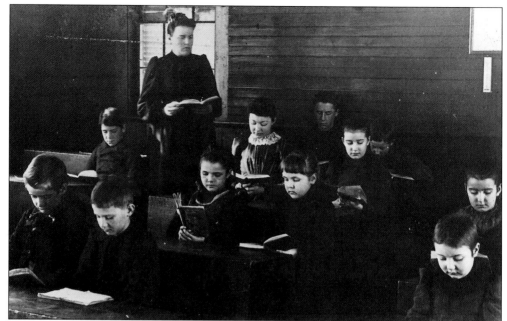

Education of children was taken very seriously if we may judge from the expressions of the pupils at the Salmon Hole classroom. It is possible that the presence of both the photographer (the children's minister) and the teacher (Anna Nickerson Howland, the minister's daughter) had something to do with the intense concentration on work in this scene. (SSN)

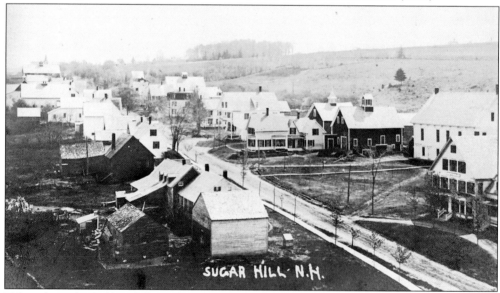

SUGAR HILL· N.H.

Taken from the belfry of the Advent Church (now the Meeting House), this 1910 view of Sugar Hill Street shows the concentration of buildings in this area. The large white building second from right is the town building and first central school. As in all rural districts, the first schools were apt to be one-room affairs scattered around so the pupils could walk to them. A fire in 1948 destroyed this school building and several others. The site became that of the Carolina Crapeau School and next to it (where the handsome barns stand in the photograph) are now the three building of the Sugar Hill Historical Museum.

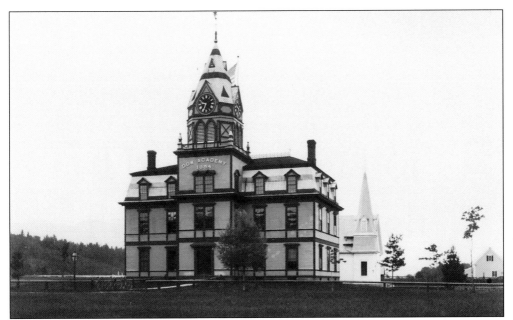

Toward the end of the century, the growing town of Franconia began to supply secondary school education to its young people. The benefactor to the community was Moses Arnold Dow, a successful publisher born in nearby Littleton, who in 1884 gave the town Dow Academy, the main building of which is shown. The curriculum included the classical languages and mathematics in addition to the basics of English rhetoric, composition, and elocution. Tragically, the building was destroyed by fire in 1902 but "rose from the ashes" to provide many more years of education of youth. It closed its career as part of Franconia College and when that too closed its doors became an apartment complex. (AWS)

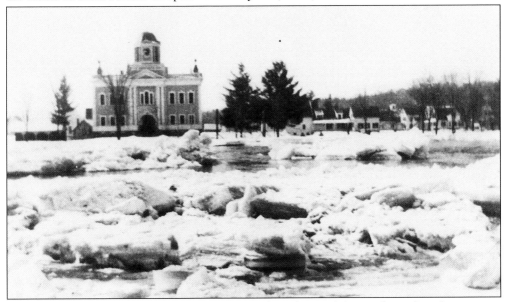

The Gale River normally flows peacefully enough in front of the academy, but this amateur photograph shows it in a "spring fling" mood as torrents from the nearby mountains break up the ice.

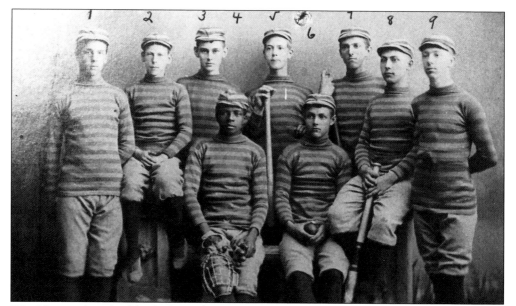

"Healthy minds in healthy bodies" was part of the Dow ethic. The baseball team organized in 1888 played their first game in May of that year: "The Rising Suns beat us by ten runs." No doubt they improved. The players are, from left to right, Chas. Bannon, Luther Whittemore, Wilbur Moulton, David Robinson, Carl H. Richardson (secretary), Harlan C. Pearson (manager and captain), Enoch Aldrich, and Henry Howland.

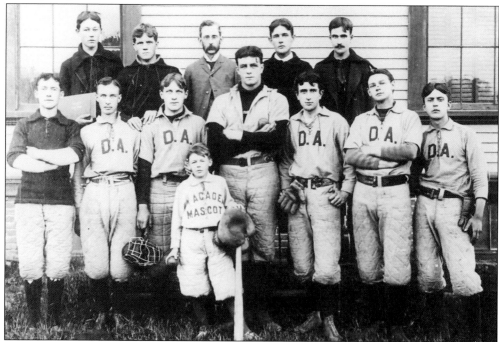

The baseball team of 1896 is shown here. Unfortunately only two members are known to us: unmistakable in the back row is Professor Ernst (headmaster) and third from the left in front is a young man who would become governor of his state, a U.S. senator, and Controller General, Fred Brown.

# Two

# The Wonders of Franconia Notch

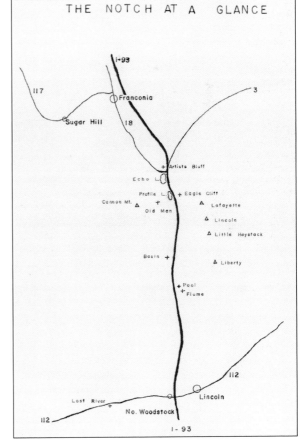

THE NOTCH AT A GLANCE

The 6-mile natural corridor of Franconia Notch has been well described by Unitarian clergyman/ author Thomas Starr King (1824–1864) as containing "more objects of interest to the mass of travellers than any other region of equal extent within (the White Mountains)." It is indeed a fitting introduction to the "Great White Hills" for the traveller approaching from the south and truly may be described as one of the region's earliest tourist attractions. Its appeal has stood the test of time.

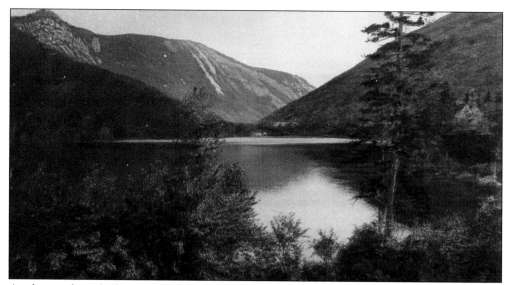

At the north end of Franconia Notch lie two sylvan pools that are a fitting prelude to the beauties to follow. At the beginning of the nineteenth century they had been rarely glimpsed by any but Native Americans, but by the time photography appeared here about mid-century, they rapidly became a favorite subject. A rocky outcrop just above the first pond soon became known as Artists Bluff, a name it retains today. It was the vantage point from which the old lithograph reproduced here was made showing Echo Lake, the beginning of the Franconia Range on the left, the Notch, and Profile Lake just hidden beyond the slope of Cannon Mountain rising to the right.

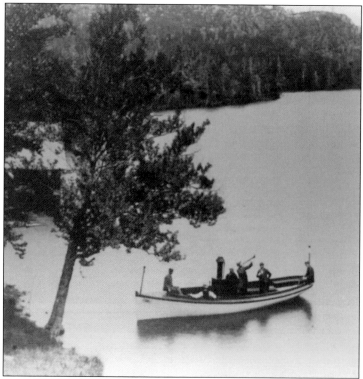

A Kilburn Bros. stereoscopic image indicates the popularity achieved by the famous echoes. Boats and tin horns were available at the boathouse for hotel guests. One entrepreneur even made a small steam launch, the *Ida*, to cruise the lake and find the best echo points. Abandoned and sunk in 1891, the remains were long visible on the lake bottom. (KB841)

Looking north along the east shore of Echo Lake, Bald Mountain can be seen with a barely discernible lookout just to the right of the lone tree. At far right is the promontory known as Artists Bluff, a favorite viewpoint looking south as seen on the previous page.

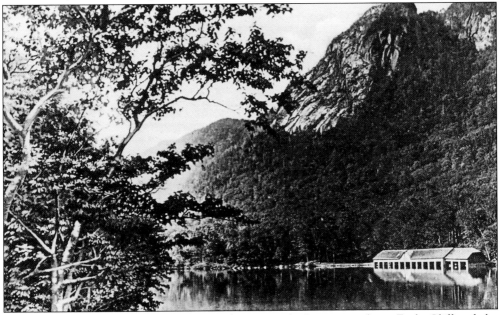

Profile Lake and its boathouse (long gone) are seen looking westerly to Eagle Cliff and the "Watcher" or "Old Woman." The face is seen looking directly at you just below the rounded peak of the cliff. It appears to this observer that there is a strong suggestion of a luxuriant beard down to the treeline so, for what it's worth, our vote goes for Watcher. However, I suppose there are those who feel if we have an Old Man there must be an Old Woman.

Precisely when a road through the Notch was opened from the south is not known. Certainly the first visitors to the area came from the Franconia region to the north. The railroad came as far up as Woodstock on the south and a spur track came down from Bethlehem as far as Profile House between the little lakes. But even though the spur was later changed from narrow to standard gauge, the lines were never joined and before this could happen the Notch became a state park. Stagecoach was the only means of public transportation through the Notch. This nostalgic old postcard gives us a glimpse of that time with Eagle Cliff standing sentinel at the north end. (PC)

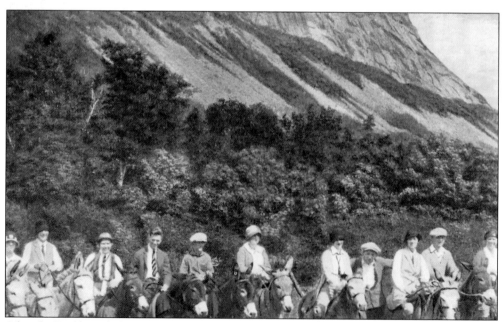

After the Profile and Flume Hotels were built, a bridle path was constructed up Mount Lafayette. Happy "burro-ists" (and it is to be hoped, happy burros) assemble for a trip, appearing to modern eyes perhaps somewhat over-dressed for the occasion. (PC)

Spectacular Mount Lafayette standing at the north end of the Franconia Range has long been a popular peak, traversed as it is by the famous Appalachian Trail on its course from Maine to Georgia. The Bridle Trail brought so many visitors from the hotels that a stone-and-timber building was erected for their shelter *c.* 1860 (above). It was destroyed by fire in 1910, but traces of the stone foundation are still visible.

Below the summit in a sheltered col, the AMC erected the Greenleaf Hut about 1929 for the use of back-packers and day hikers. Enlarged and improved, it is a popular stop-over for today's hikers.

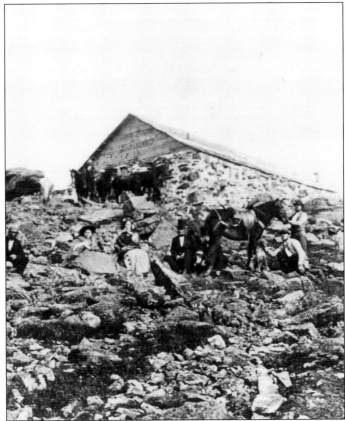

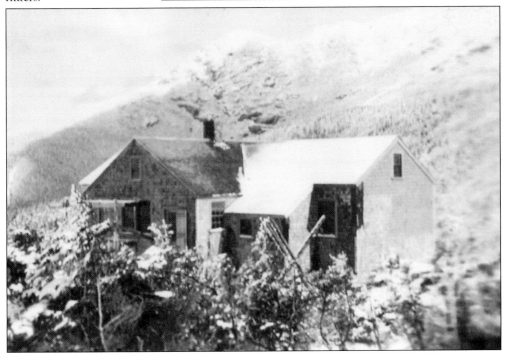

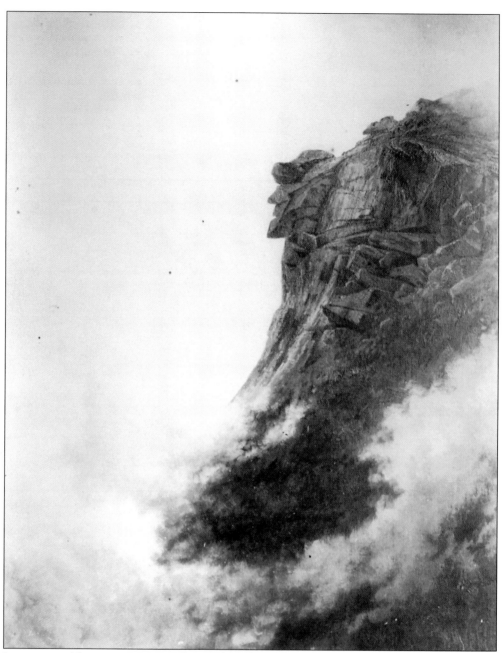

It is not possible even to estimate the number of cameras that have been pointed at this famous rock formation in Franconia Notch near the top of Cannon Mountain, affectionately known as the Old Man of the Mountains. (The plural form seemed most common in earlier years but the tendency now seems to be to allow the Old Man only one Mountain.) One of the early photographs of the venerable visage was made by Littleton's world-renowned stereographer, Benjamin W. Kilburn. With his slight tendency toward poesy, he entitled his fine picture "Enthroned Among the Clouds" and copyrighted it in 1880. The picture has been reproduced countless times but this one is from an original albumen print in the collection of Littleton Historical Museum. (BWK #21)

Painters too have been irresistibly drawn to exercise their skills on the Old Man. Herewith is an oil by Edward Hill who lived and worked in New Hampshire for some thirty years. Hill was artist-in-residence at Profile House for fifteen summers and concentrated his efforts on the Franconia region, putting on canvas all the best-known scenes, which certainly did something to attract so many thousands of visitors to the area. (Reproduced with kind permission of the Littleton Public Library.)

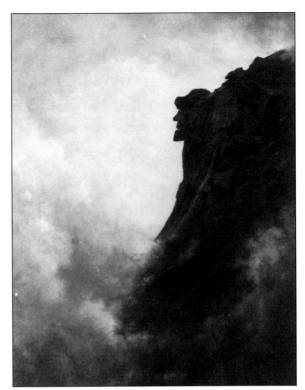

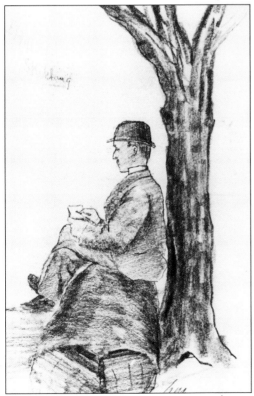

A Littleton resident and personal friend of Edward Hill's, George Tilton, left us this pencil sketch of the artist at work, now in the collection of the Littleton Historical Museum.

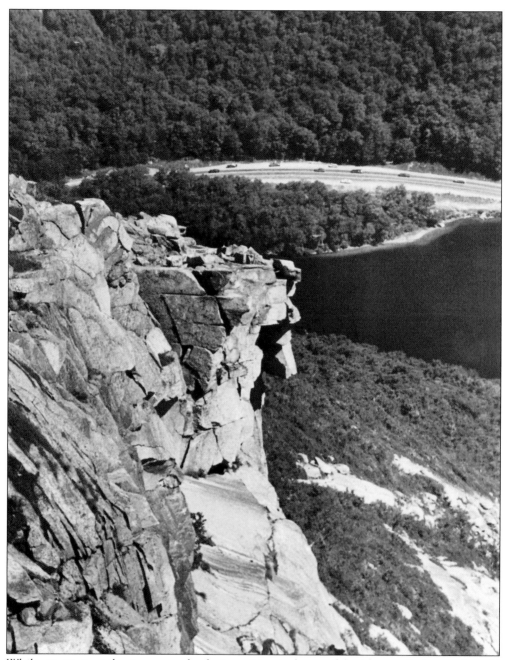

While we try to make it a general rule in writing to be careful with superlatives and avoid absolutes, it would seem safe to say that this view of the right profile of the Old Man is one you are not likely to get unless, like the photographer, you hover (preferably by helicopter) 100 feet or so above the cliff and uncomfortably close the top of Cannon Mountain. (DHP)

# THE *Old Man* OF THE MOUNTAINS

## PAST AND PRESENT EFFORTS TO SAVE THE GREAT STONE FACE

BY
MABELLE GEDDES RUSSELL

Looking at the Old Man, one feels that nothing could be more permanent than this granite mass. Not so. New Hampshire's "greatest scenic asset" was at one time literally within inches of total destruction. The highlights of this story have been culled from two sources: a rare pamphlet written by Reverend Guy Roberts of Whitefield; and a booklet written by the late daughter of the wonder-worker, Edward H. Geddes.

1872: An AMC group located the face from the top and discovered the slab that forms the forehead was in imminent danger of slipping off and plunging 1,200 feet to the valley, probably taking the nose with it.

1906: The Reverend Guy Roberts located the top of the profile. He took photographs and measurements, confirming the danger. The Profile and Flume Hotels Co., which also owned the Old Man, investigated and received the report that nothing could be done to avert the catastrophe.

1915: Edward H. Geddes, a Quincy, Mass., quarry superintendent visiting in the area, accompanied Reverend Roberts to the spot and worked out a plan, making careful measurements of chiseled marks in the stone.

1916: A second visit by the two men revealed that the forehead stone had moved about an inch toward the abyss. As only about 40% of the slab rested on the ledge, the rest hanging out into space, it was estimated that 4 more inches of slipping would result in the inevitable.

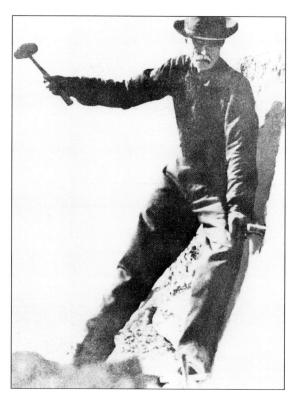

In September and October of 1916, the fifty-year-old Edward Geddes climbed the 1,900 feet of elevation, usually carrying a minimum of thirty pounds of gear and materials, and worked at installing the iron rods that would anchor the slipping stone to the parent ledge. Men were hired to carry loads of necessary material and supplies up the same path but on only one day did Geddes have another worker. Nearby Mount Washington boasts the worst weather in the world but Cannon Mountain in October can be also unkind and this incredible man suffered frostbitten fingers that required medical treatment.

His job completed, Mr. Geddes descends over the face on ropes fastened to his new installation for no reason that can be fathomed other than to give a celebratory wave of his hat. Both photographs were taken by Reverend Roberts, who evidently visited the work site as often as his duties would allow. The pictures on this and the preceding page are reproduced with the kind permission of the Littleton Area Historical Society.

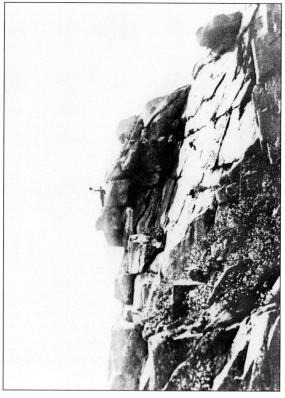

This model was handmade by Mr. Geddes of wood and brass and is now in the Littleton Historical Museum. It was used to convince first the owners of the Old Man and then Governor Spaulding that the project was feasible. The state agreed to pay the bills, as it was becoming increasingly obvious the Old Man was a very large asset to the growing tourist industry. The model shows only how the slipping stone would be attached to the ledge. At lower right the Lewis pin is exposed to show how it is locked in place.

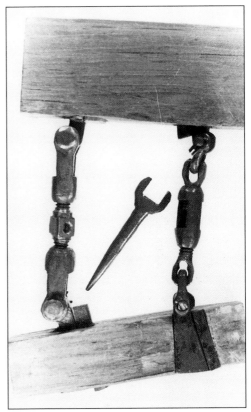

Some ten years after the completion of this heroic task, the Reverend Roberts found that a dam of loose stones built to protect the mechanism had been damaged and needed major repair. He was able to secure the services of five young men and on October 14, 1927, they rebuilt the wall, setting the stones in concrete. The group then headed happily, if wearily, back down the same day. Four of the five are shown in this photograph. From left to right are Harry Hodge, Howard Bronson, Arthur Albee, and Robert Poor, all of Landaff. The fifth member was Carl Young.

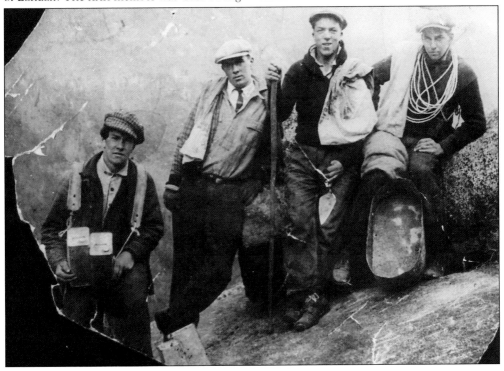

Located about halfway down the Notch on the west side, the Basin is so-called for the deep circular pool that the Pemigewasset River has scoured out of the granite by constant abrasion of the water-borne grit and stones. First named "Agassiz Basin" for the great Swiss-American zoologist and geologist, the landmark's name has been shortened in recent times, no doubt to make the signs less expensive. Always a fascinating place to visit, the Basin is really impressive when the spring freshets come roaring down between the huge blocks of granite.

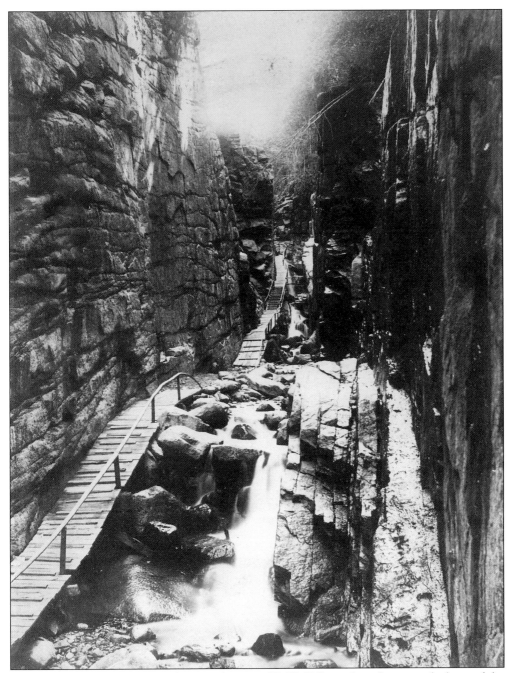

Again we are indebted to the photographic art of B.W. Kilburn for a fine record of one of the most impressive scenes in the Notch—the Flume Gorge. This is a huge defile some 700 feet long with walls 50 to 70 feet high, through which courses the Flume Brook descending from the mountain of the same name. The original photograph is a 7-by-9-inch albumen print dated 1883, presumably taken after June of that year when the famous boulder was dislodged in a flood (see next page). (BWK)

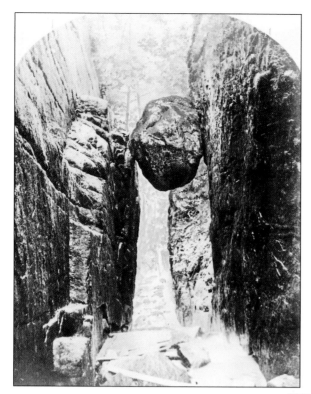

For uncounted eons this huge boulder hung suspended between the walls of the gorge in, to quote Starr King, "a grasp out of which it will not be dislodged for centuries." King was right in a way, but the centuries came to an end on June 20, 1883, when a torrent (some say avalanche) following a cloudburst dislodged the boulder. The photograph is a copy of a stereoscopic half, photographer unknown.

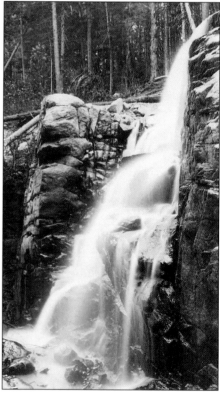

The Flume Brook begins its course through the Gorge with this fittingly spectacular waterfall known as The Cascade. The original photograph is a well-preserved 4.5-by-8-inch albumen print by C.P. Hibbard, who was working at this time in Lisbon. (CPH)

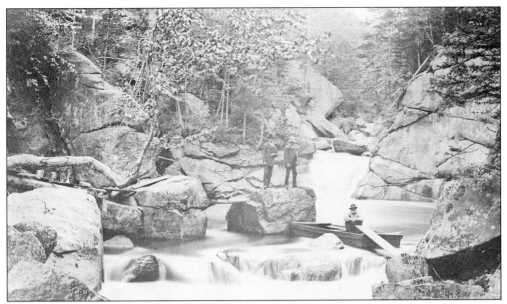

A short walk north of the Flume leads to another of the famed beauty spots, The Pool in the Pemigewasset River. As unlikely as it seems, an early entrepreneur installed a boat for the further edification of daring travelers, who evidently were required to board by "walking the plank." (BWK)

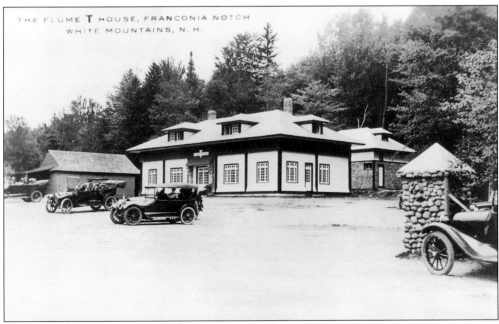

No doubt a welcome sight to early motorists in this "remote wilderness" was the T-House, where refreshments and souvenirs were available. The site is now occupied by the buildings of the Franconia State Park Headquarters. (PC)

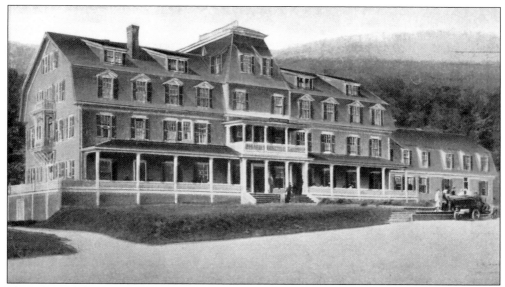

The other of the two major hotels in the notch (see the Profile House, p. 56) built by the owners of the area (Taft and Greenleaf) under the name of Profile and Flume Hotels Co. was the handsome Flume Lodge. Located at the south end of the Notch, it could be reached by the railroad that came up from Plymouth as far as North Woodstock. Travelers through the Notch to the north had to take the stagecoach from here. (PC)

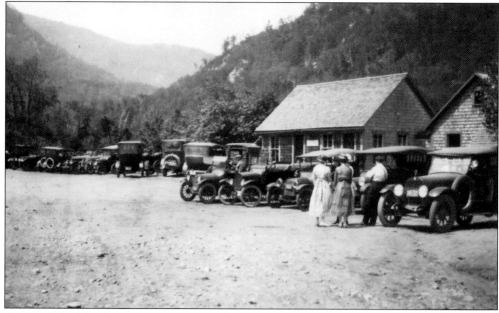

A tour of the Notch wonders is not complete without a visit to Lost River a few miles west of North Woodstock on Route 112. Here the Moosilauke Brook dives underground into "caverns measureless to man," some of which can be toured by intrepid visitors. Although somewhat off the main north-south route, it has since its discovery in the early nineteenth century attracted a constant stream of visitors. The photograph is a postcard-size, gelatin-silver print labeled "Lost River Parking Lot, Dining Room and Cook House, 1920." On the reverse is the signature of James R. Randolph. (PC)

The view eastward from Breezy Hill in Lisbon overlooks Sugar Hill. Franconia is mostly hidden in the valley except, as always, the Forest Hills Hotel is visible at left center. The mountains fade away in the distance, concealing the corridor of beauties that we call Franconia Notch. (CPH)

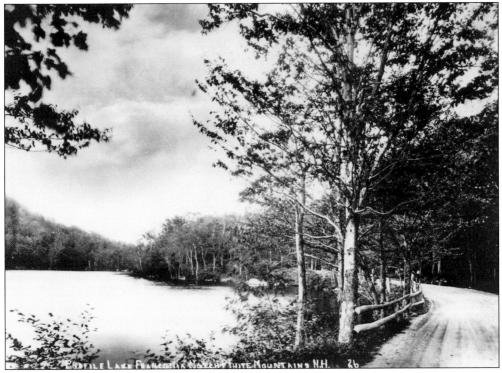

This image provides a nostalgic last look at Profile Lake before the highway came. (PC)

People of New Hampshire have good reason to be grateful to this man. Phillip W. Ayres was forester for the Society for the Protection of New Hampshire Forests in 1925. This forward-looking group brought to the attention of the New Hampshire Legislature the real danger of destruction of Franconia Notch through commercial exploitation. Then privately owned by the Profile and Flume Hotels Co., the 6,000-acre tract known as Greenleaf Park included all the wonders that have been described in this section.

To their everlasting credit, the legislature voted the sum of $200,000 to be used toward the purchase of the area, priced by its owners at $400,000. The SPNHF demonstrated the seriousness of their commitment by donating another $100,000. Ultimate success was assured when the New Hampshire Federation of Women's Clubs easily raised the last hundred thousand dollars. In June 1928, the people of New Hampshire became the owners of this unparalleled bit of real estate.

# *Three*

# Enter the World

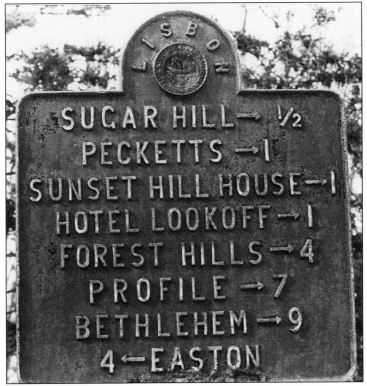

This handsome, old cast-iron sign still stands on Sugar Hill Street at the corner of Easton Road, although the hotels listed are long gone. As indicated at the top of the sign, Sugar Hill was still part of Lisbon when the sign was made, perhaps about 1900.

It was without question the beauties of Franconia Notch that first attracted travelers in sufficient number to warrant the construction of the large, summer hostelries. One of the earliest of these seems to have been the Lafayette House, erected in 1835 by S.C. and J.L. Gibbs on what is now the public campground known as Lafayette Place. The famous Profile House was to follow shortly, and down in the village the Forest Hills Hotel. The construction of new buildings and alteration of old farmhouses continued on the road out of Franconia to Sugar Hill. The railroads made the phenomenon possible; the automobile ended that era but opened another. The business of being hospitable hosts is very much alive and well in these two small hamlets.

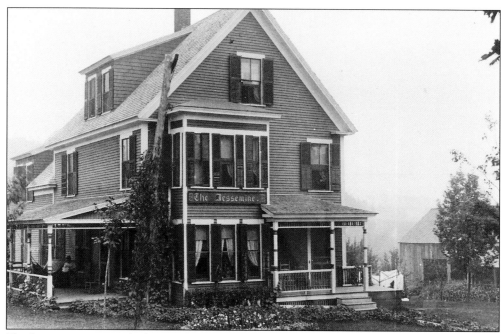

The Jessamine, operated of course by the old established Jesseman family on Sugar Hill Street, is an early example of the use of private homes, with more or less adaptation, as rooming houses for summer guests.

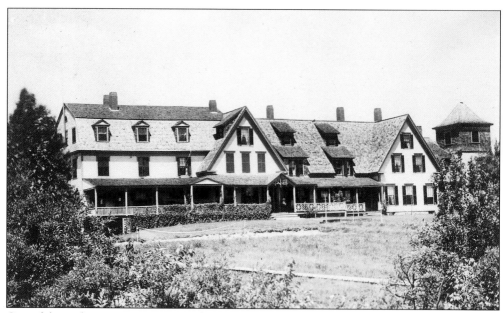

One of the early very impressive inns built expressly for the purpose and located near the Sugar Hill-Franconia line not far from the old iron furnace was the Miramonte, built in 1890.

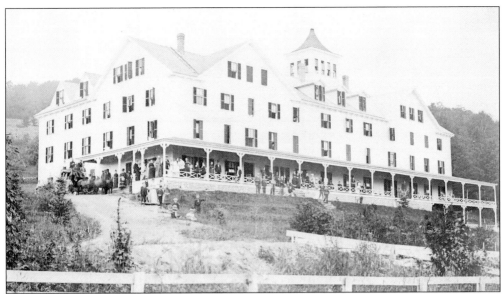

Two views of the same building bearing different names mark the beginning of an era within the era. This structure too was on the road leading up to Sugar Hill from Franconia Village on land that was later to be acquired by the father of Robert P. Peckett of Peckett's Inn fame. The upper photograph bears the printed label "Goodnow's House," and the lower "Franconia Inn." This building burned in 1907 and is not to be confused with the later Franconia Inn (see p. 99). (KB) (CPH)

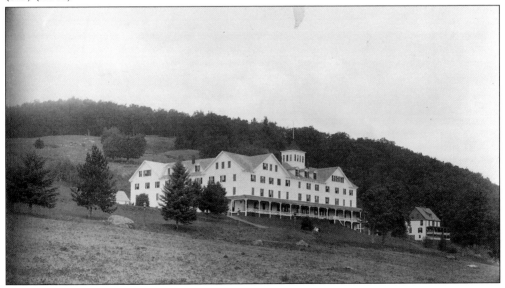

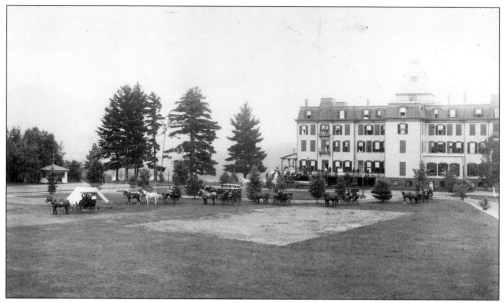

These two views feature a well-remembered Franconia institution with a long and one might say checkered career, the Forest Hills Hotel. Built in 1882 just outside the village on the road to Bethlehem, it served its purpose very well until 1956, when the entire property was donated to the University of New Hampshire and served for a while as the School of Hotel Management. In 1960 it was sold to the Trustees of Franconia College and opened its doors to the first class three years later. What might be termed an experiment in modern education lasted about a dozen years, after which the college was closed.

Of particular interest here, however, is that with the addition of "The Lodge" in 1894 to accommodate winter guests, the hotel was one of the earliest to recognize the promise of winter business in the developing interest in outdoor winter recreation. (CPH)

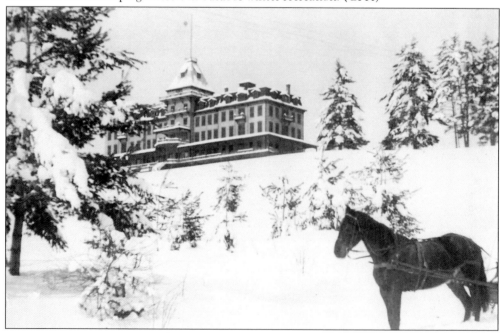

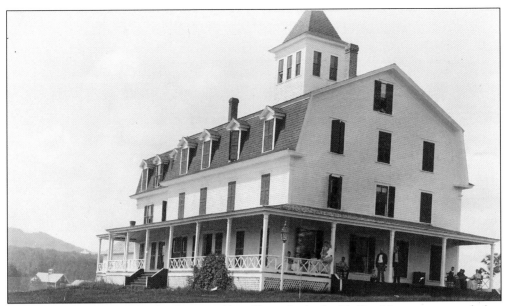

A relatively modest building by the "grand hotel" standards, the Phillips House was nevertheless an impressive structure. Standing on a hill in the Lovers Lane area of Sugar Hill, it quite obviously commanded an impressive view and no doubt had its faithful clientele, some of whom are seen on the shady porch.(CPH)

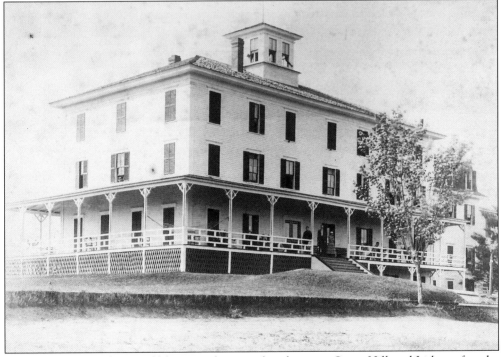

Located just over what would become the town line between Sugar Hill and Lisbon after the two parted company, the Breezy Hill House opened its doors to guests in the summer of 1909. Located on the high ground above the Salmon Hole Brook, the hotel provided, in addition to the view, some pretty fine entertainment in the fishing line. (CPH)

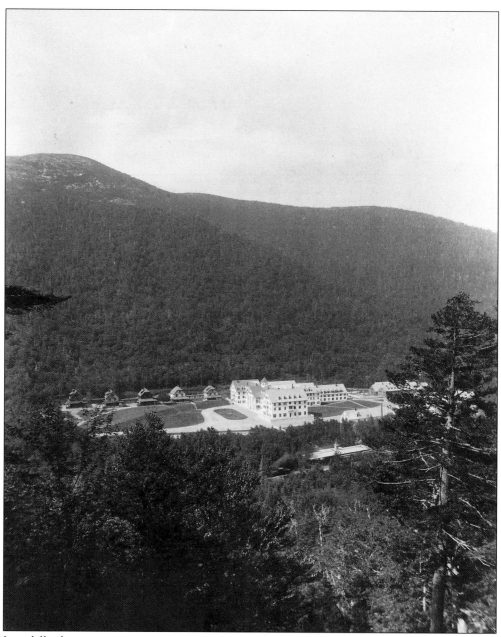

It is difficult to imagine a more majestic setting for a hotel complex than that of the Profile House and Cottages in Franconia Notch. Taken about 1890, the picture showcases the view from part way up Mount Lafayette. Nearest to the viewer is the roof of the station and a train standing in front. Beyond are the main hotel buildings and the row of "cottages" (some with ten bedrooms!).

The little railroad spur connecting with the main line in Bethlehem and the primitive roads north to Franconia Village and south to Woodstock, together with a telegraph line, linked the Profile House to the world.

The complex was built by Richard Taft and Associates in 1852–53. Colonel Chas. H. Greenleaf became a partner in 1865; additions were made in 1866 and 1872.

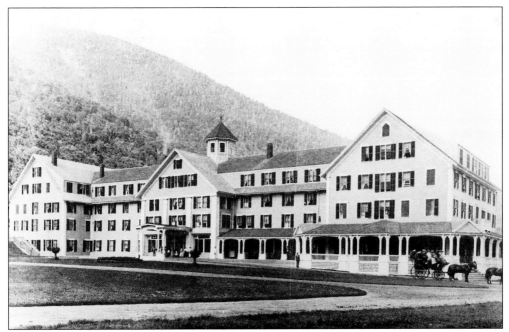

Here is another view of the imposing facade of the first Profile House, which, in the author's opinion, was architecturally more attractive than its successor. The crowning cupola, the porte cochere below (from which the four-horse carriage has just left and is rapidly moving out of the picture to the right), and the handsome porch pillars all lend a pleasing ambience of gracious living.

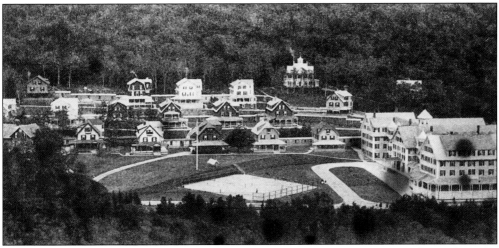

A somewhat later view is this postcard picture, which shows the covered walkway from the more numerous cottages to the dining room and the newly added tennis court. What happened to this magnificent structure seems not to have been dependably recorded. Some say it burned, but if this were so it surely seems the fact would be well established. More likely is that for unknown (probably structural) reasons, it was at least partially demolished and the second one built on the same foundation.

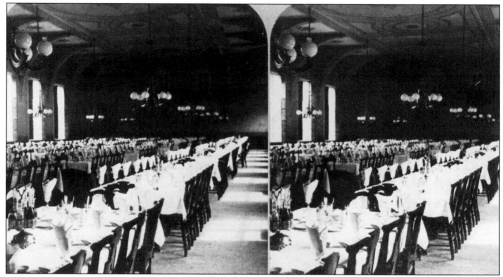

Two stereoscopic prints by C.P. Hibbard are reproduced here in full so that if you happen to have one of those small hand viewers you can appreciate the length of the dining room and the beauty of its ceiling. The kitchen staff (below) seem to have been photographed out in back of the hotel, but who's surprised?

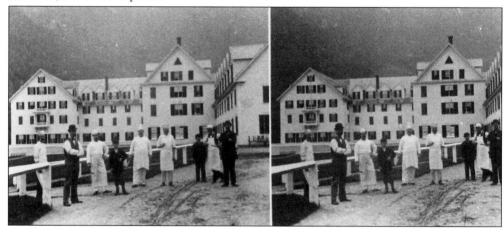

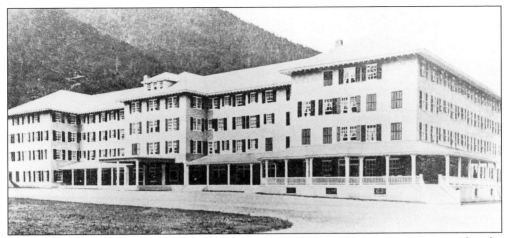

Sometime around the turn of the century, the first beautiful Profile House was converted to the building above, seemingly of the same general dimensions but with a very different roof and a generally more severe appearance. No doubt the internal improvements were greater than the external, as the operation continued to flourish for another two decades.

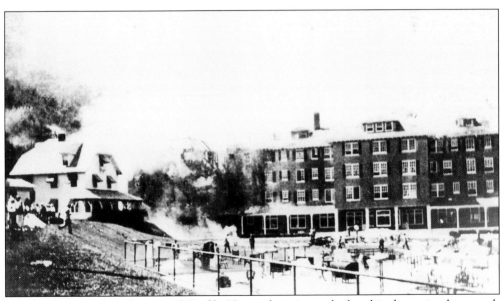

Of what happened to the second Profile House there is no doubt; this dramatic photograph taken August 23, 1923, tells the story. As was inevitable at that time and place, the flames advanced inexorably to consume almost the entire complex. An occasional brick or shard of glass may be found along the Pemi Trail today to remind us of this astonishing enterprise. It was the end, not only of a grand hotel but the beginning of the end of a grand era.

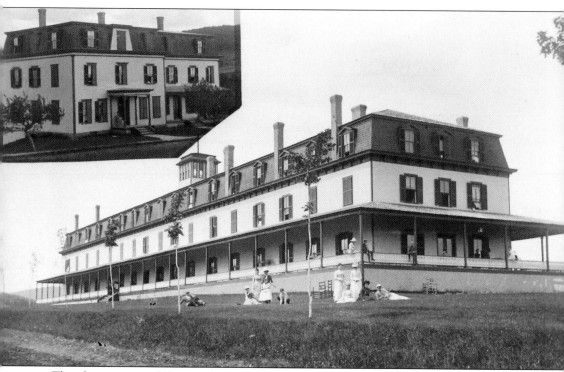

The phenomenon of the grand summer hotels was created by the railroads and ended largely by the automobile plus improved economic circumstances of the average American beginning in the latter part of the twentieth century. The railroads brought well-to-do families out of the cities to spend weeks or months in the scenic as well as healthful mountain surroundings. The automobile, on the other hand, began a period of travel freedom for an increasing number of people. The one- or two-week vacation was becoming standard, and with rapidly improving highways (U.S. Route 3 extended almost the length of the eastern seaboard by mid-century) it became possible to travel hundreds of miles during the vacation, staying for a night or two in the economical "overnight cabins" that soon dotted the major highways and getting something resembling a meal at hot dog stands, which were even more numerous. But more on these changes later.

We have selected as our prototype of summer hotels the one pictured above, The Sunset Hill House in Sugar Hill, for two reasons: first, by entertaining summer guests for only a few years short of a century, it is one of the oldest and second, for the very practical reason that a marvelous photographic record has been preserved. The photograph shows the main hotel building in its early years (it was built in 1880); in the inset is the annex added later that is now the year-round Sunset Hill House. Read on.

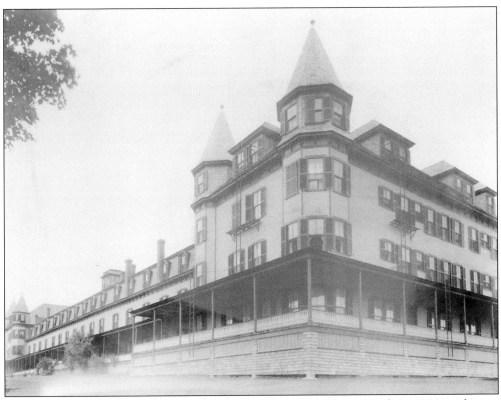

The unusual angle chosen by the photographer to show the additions made in 1914 emphasizes the mass of the huge structure. (ONA)

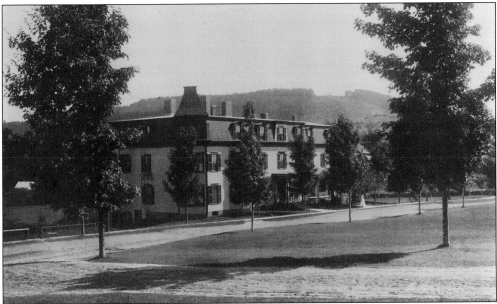

The annex, first built for staff members, later became with additions and alterations today's Sunset Hill House, providing year-round accommodations. The view remains the same, as does the golf course (see p. 62).

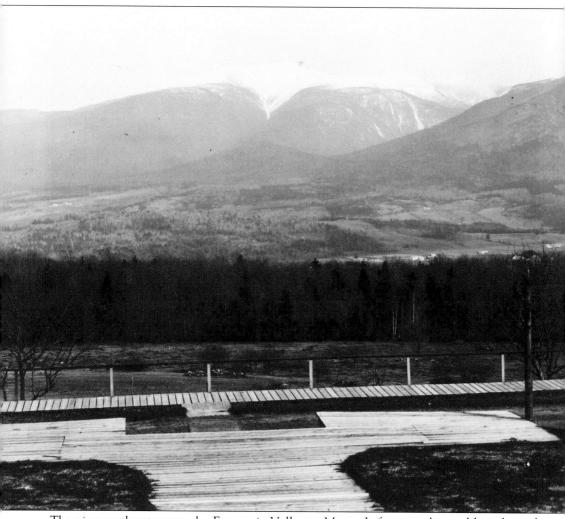

The view southeast across the Franconia Valley to Mount Lafayette, whitened here by early frost or a dusting of snow, was surely (and still is) one of the feature attractions of the Sunset Hill House. The old boardwalk was probably replaced a number of times before a more durable, if less attractive, material was used.

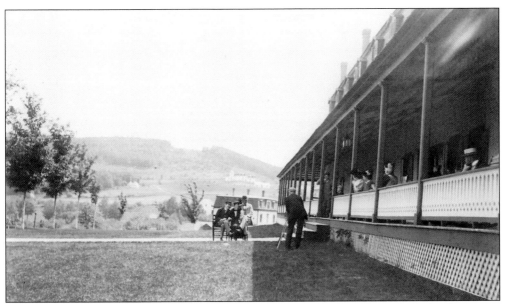

Photographers are seldom photographed, but the Reverend Mr. Nickerson caught this one at work in front of the hotel.

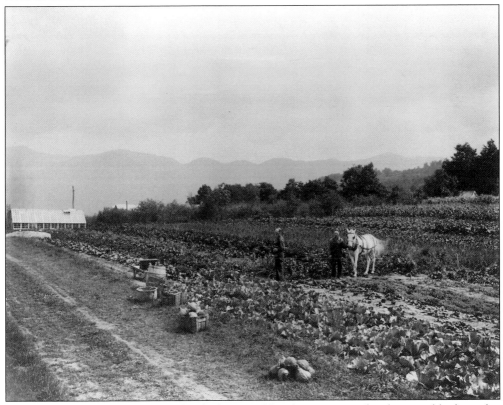

Of scarcely less attraction were the fresh vegetables that came to the dining table from this extensive garden, well tended by Mr. Sawyer (holding hat), Pat, and Jerry (white with four legs).

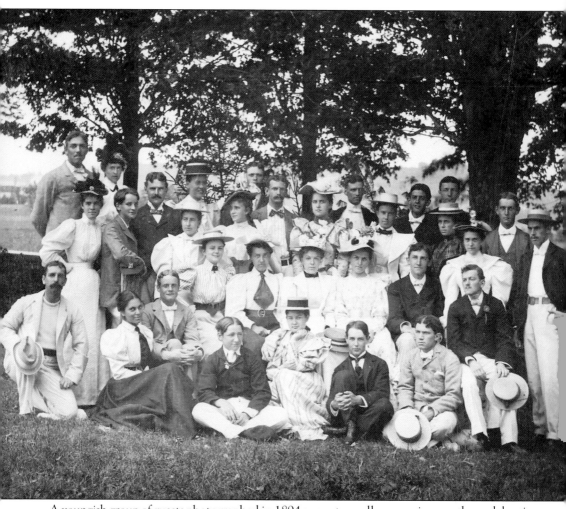

A youngish group of guests photographed in 1894 suggests a college reunion or other celebration. Note the cap with the "H" on the post and "Ely" on the hatband of the pretty young lady in the high-collared striped blouse.

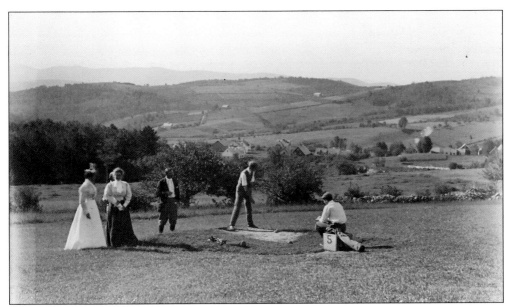

A nine-hole golf course appeared early on the spacious grounds of the hotel; guests could tee off almost from the front door. The magnificent views afforded by the hotel's elevation may have helped heal the wound of a missed putt. Plus-fours were perhaps something of a novelty at this period; the ladies appear to be more observers than participants.

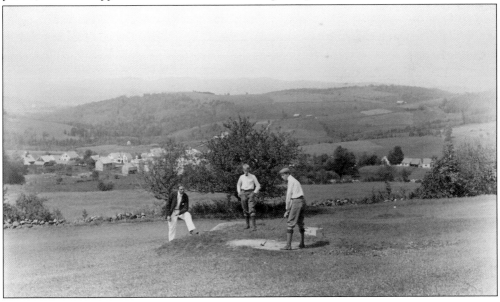

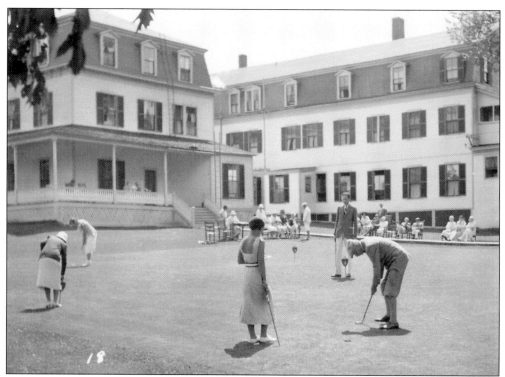

Popularity of the sport and increased participation by the ladies is evidenced on this putting green near the main buildings, probably photographed about 1930. The golf pros and caddies arrange themselves, no doubt according to the photographer's instructions, around the clubhouse, which was also used for amateur theatricals and other informal entertainment.

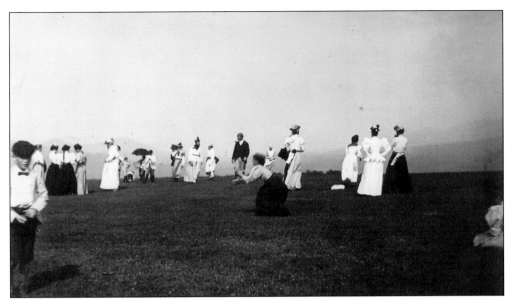

In spite of the voluminous skirts, athletic young women managed to exercise their skills at sports like baseball, tennis, and golf before fashion permitted them to wear clothing more suited to the purpose. This photograph is labeled "Baseball, Sunset Hill House, 1895."

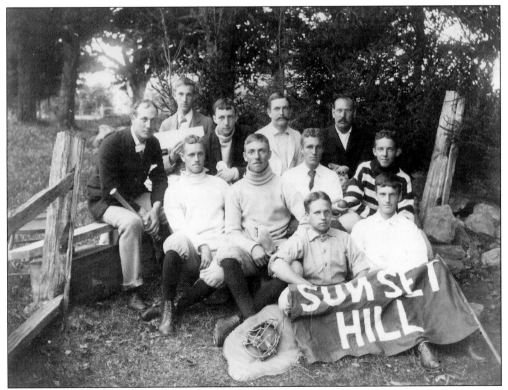

It seems that almost every organization of any kind that could muster up nine men or boys had a baseball team, and Sunset Hill House was no exception. We have no identification of any of these fine-looking young men. The maker of the banner was a little careless. (MS)

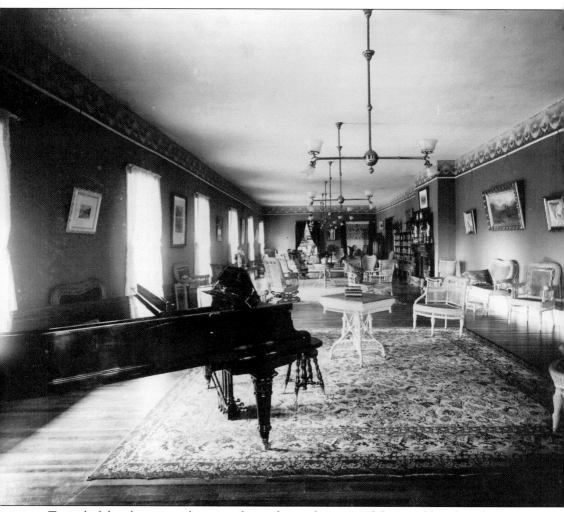

Typical of the elegance and gracious living featured at most of the grand hotels is this room in the Sunset Hill House with its handsome grand piano, wicker furniture (for which a modern collector would pay a small fortune), and elegantly framed pictures. The fireplace at far right served more than a decorative function on chilly days.

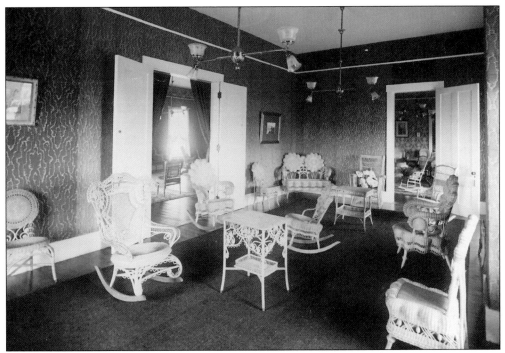

Two more interior views suggest the elegance enjoyed by guests at the grand hotels. Hard to believe the wood paneling was installed piece by piece, each board cut by hand, long before the days of machine-made, 4-by-8-foot sheets.

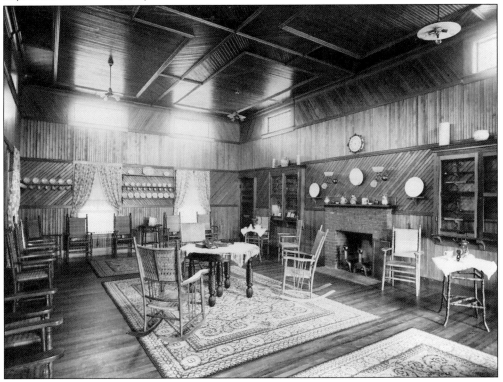

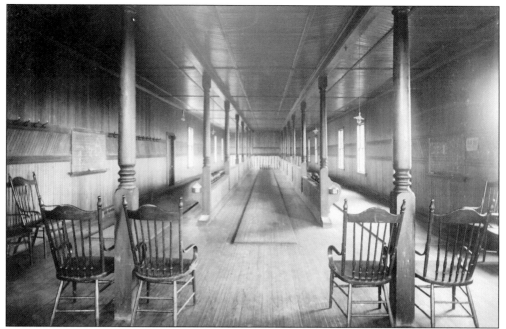

The bowling alley looks strangely deserted (the photographer didn't want people getting in his way?), but was no doubt a popular spot on rainy days.

The impeccably uniformed and groomed young men who answered to the call of "Front" pose here in a setting quite obviously selected by a professional photographer who did not leave us his or her name. The only young man who has been identified to date is Calvin Morgan, standing at left.

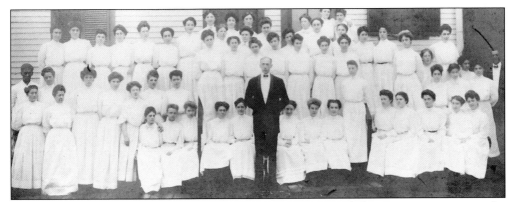

For once we have a different problem: the name of every young lady waitress is written on the back of the mount of this 1907 gelatin-silver print, but these are a bit numerous to fit in here. The head waiter (center) and second head (far right) were evidently too well-known to require writing out their names.

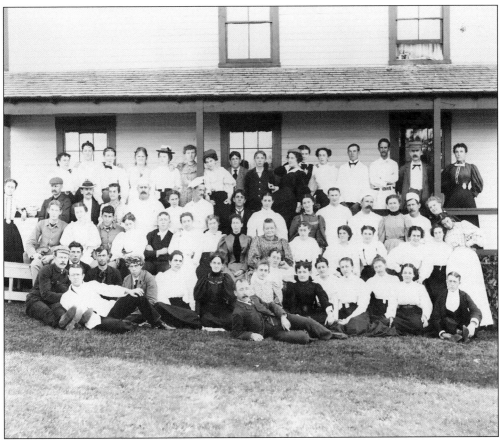

The two photographs on this page of Sunset Hill House staff emphasize the size of the operation; it was truly a small, self-contained community. The people and their functions remain a mystery other than what we can deduce from their attire, but the gentleman lounging (somewhat unconvincingly) in the center foreground might well be the manager.

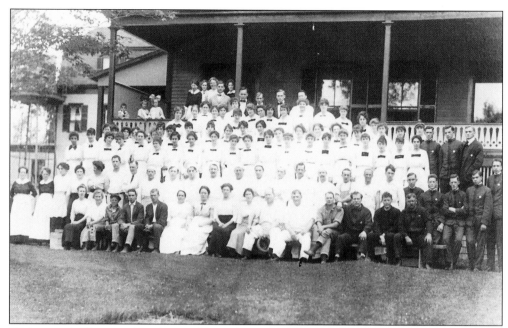

Waitresses, bellboys, and kitchen and housekeeping staff seem all to be included here as well as three children at the corner of the piazza.

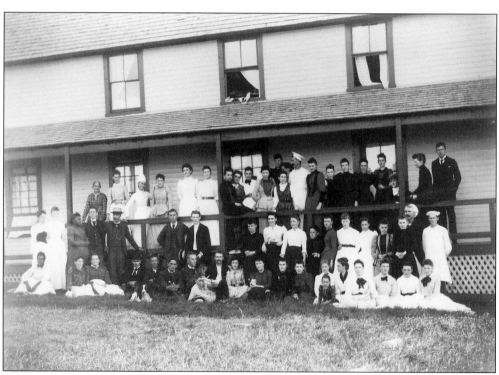

Again one cannot help but be impressed by the size of the staff and, as most of them lived in quarters on the premises, how much of a mini-community this really was.

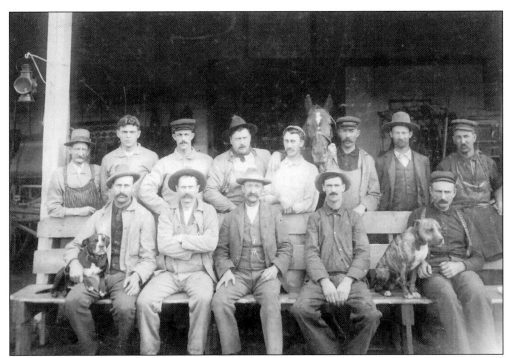

The teamsters and stable crew were a vital part of the operation before the guests started arriving in their own automobiles, mostly after World War I. Carriages and wagons were required to transport guests and voluminous luggage to and from the depot and to take them to the many points of scenic interest, including the tops of several mountains. The photograph of the stable crew complete with one horse and two dogs was taken in August of 1902. The owner of the dog on the left is Harvey Bishop; the others remain unknown.

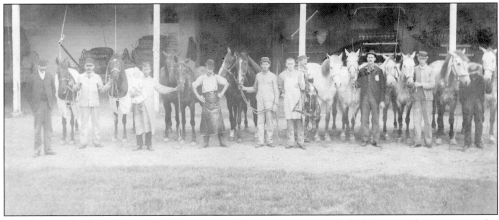

A rather badly faded, nineteenth-century albumen print is included here to do justice to the faithful "prime movers" before the days of internal combustion engines.

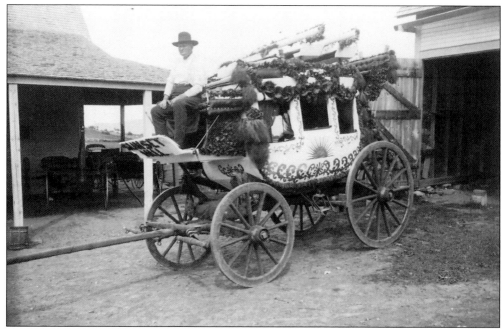

Another entry for the popular Bethlehem Coaching Parade will be driven by J.B. Elliott, as soon as the horses have had their oats.

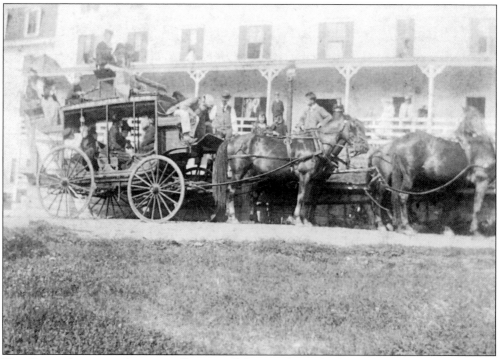

The Concord-type coaches were all very well for parades and other gala events, but there was also the mundane work of transporting passengers and their voluminous baggage to and from the railroad station, and carrying tourists to the numerous scenic spots. This is the Breezy Hill utility wagon.

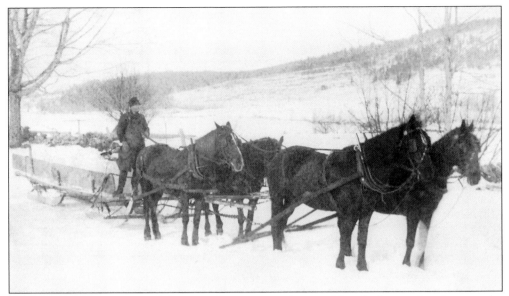

Ice cubes did not pour out of electric refrigerators in the grand hotels. Ice was hand cut on the ponds in the winter with 6-foot ice-saws, loaded into pungs, and hauled to the icehouses, where it was packed with sawdust for insulation.

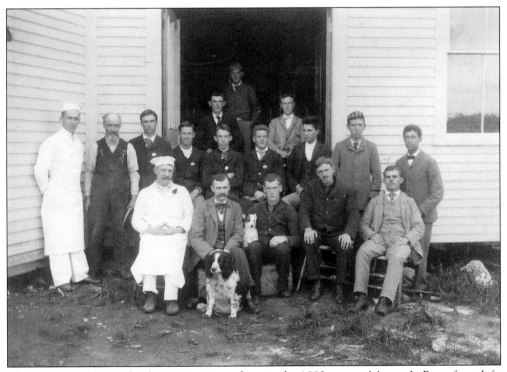

The Sunset Hill House kitchen crew appears here in the 1892 season. Marcus L. Page, front left, was head cook. Medford, next to him, was head dog.

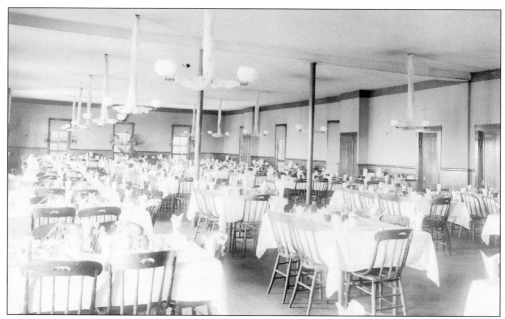

The dining hall at Sunset Hill House was complete with linen napery kept snowy white by hard-working laundresses.

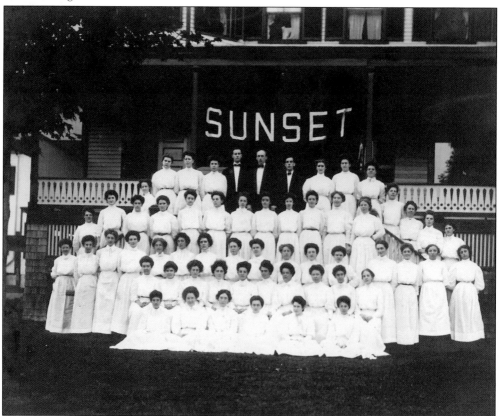

The ladies and gentlemen who served in 1908.

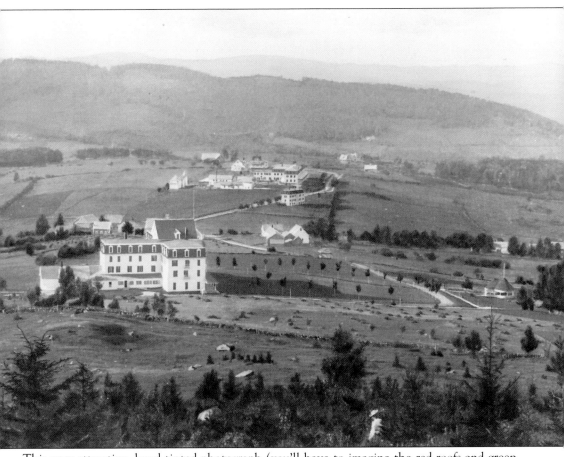

This very attractive, hand-tinted photograph (you'll have to imagine the red roofs and green lawns) gives us a fine bird's-eye view of the Hotel Lookoff in the foreground and the Sunset Hill complex in the distance. No more words needed.

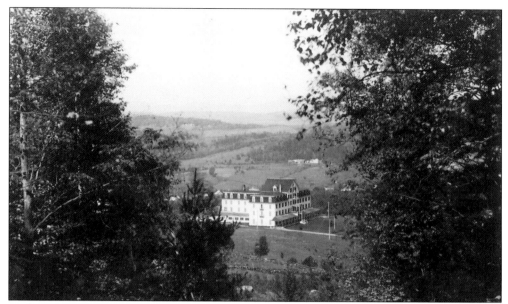

A closer look at the Lookoff . . . (CPH)

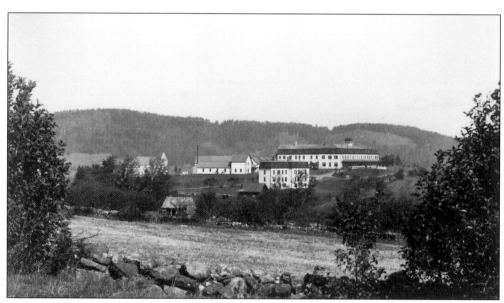

. . . and at the Sunset Hill House.

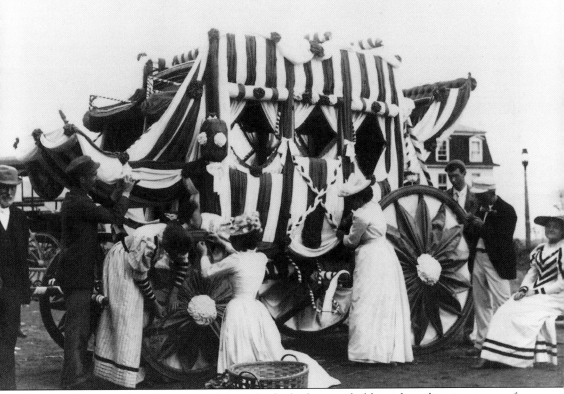

The coaching parades, the most celebrated of which were held in the adjoining town of Bethlehem, were the occasion for days of elaborate preparation. Here guests of the Hotel Lookoff, having evidently arrayed themselves first, put the finishing touches on their entry.

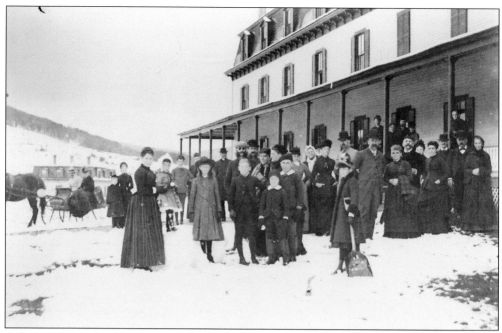

A fitting closing for this section and introduction to the next are these two snow scenes at the Sunset Hill House, which were presumably taken in October after an early dusting. The guests produced the warmest clothing they'd brought for a summer vacation; the little girl must have borrowed the shovel from the barn and (below) the cutter was hitched up for a spin over sparse snow. And, of course, can there be a snowfall without a snowman?

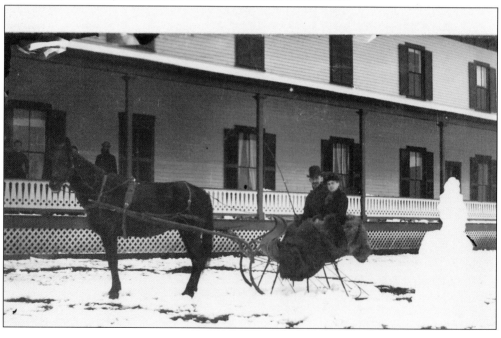

# *Four*

# Winter Becomes a Friend

The monstrously large summer hotels became white elephants (perhaps mastodons?) with the coming of the automobile and a changing economy. Those that did not burn, accidentally or otherwise, were razed, their contents and some of the fabric sold at auction.

Other than the auto and the socioeconomic changes that came along shortly after, perhaps the chief reason for their demise was the growing recognition that winter could provide healthful outdoor recreation: sledding (bob-sleds holding ten or more people were common), snowshoeing, tobogganing, and then came skiing, which was to transform the economy of this area and many like it. How this came about is the subject of this section.

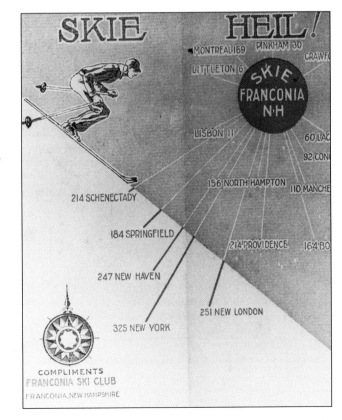

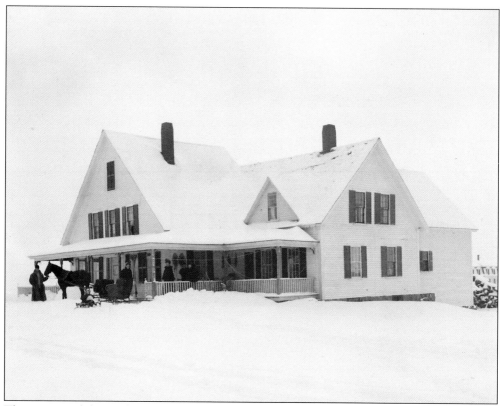

The coming of the Peckett family to Sugar Hill was in a very real sense the beginning of the winter tourist business in this area. John Wesley Peckett, a successful New York attorney, had brought his family here to spend healthful summers at John Goodnow's boarding house. In 1876, together with Goodnow, John Peckett constructed the imposing Goodnow House pictured on p. 53. When his son Robert was twenty-one, he and his brother John took over the operation of the hotel, changing the name to Franconia Inn, but it was destroyed by fire in 1907. In the meantime, Robert had married Katherine Belknap of Littleton and the couple made their home in the original farm boarding house pictured above in 1900. This unlikely-looking structure was to become the nucleus of the widely-known and much-loved Peckett's-on-Sugar Hill.

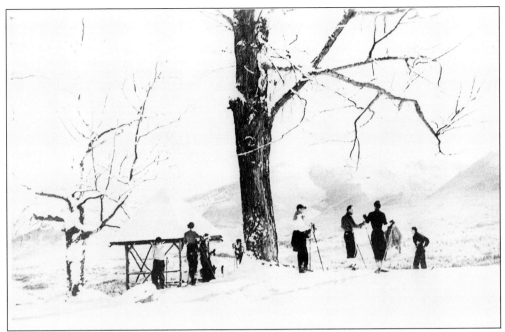

In the late 1920s, the Robert Peckett family (they now had three children), seeing the growing popularity of skiing in Europe, cleared a slope on their spacious property and began to introduce their guests to the gentle art of sliding downhill on long boards strapped to the feet. What the future held for the pastime, no one could possibly imagine. Ladies wore whatever seemed practical and, of course, fetching. Riding breeches were popular and long woolen scarves de rigueur. Gentlemen for a time satisfied themselves with golf knickers, tweed jackets over flannel shirts with, of course, wool neckties. Who could believe what Mrs. Bogner and her stretch pants would later do to the scene?

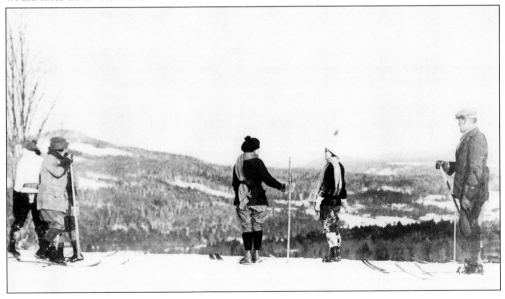

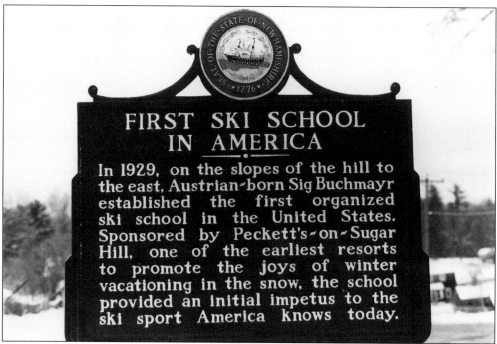

# FIRST SKI SCHOOL IN AMERICA

In 1929, on the slopes of the hill to the east, Austrian-born Sig Buchmayr established the first organized ski school in the United States. Sponsored by Peckett's-on-Sugar Hill, one of the earliest resorts to promote the joys of winter vacationing in the snow, the school provided an initial impetus to the ski sport America knows today.

Not people to do things by halves, the Pecketts imported ski instructors from abroad and set up what the State of New Hampshire has chosen to describe as in the historic marker above. There are those of course who will quibble over the statement, but it serves the purpose.

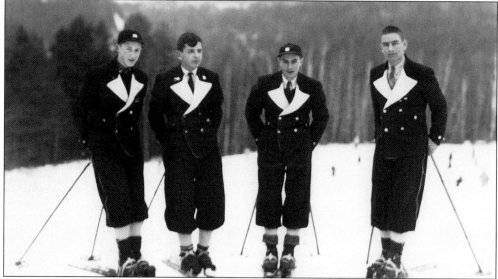

Young men in the area took to skiing like the proverbial ducks to water. Under the tutelage of Sig Buchmayr, they were soon aiding in the instruction, forming a genuine ski school. To promote sales of newly designed ski clothing, Saks Fifth Avenue built a wooden slide in their New York store, covered it with Borax and invited Sig and the boys to demonstrate the art. Three of the four are hale and hearty today, and it is doubtful they have forgotten a single detail of that event. From left to right are Roger Peabody, Bobby Clark (killed in World War II), Bert Herbert, and Norwood Ball.

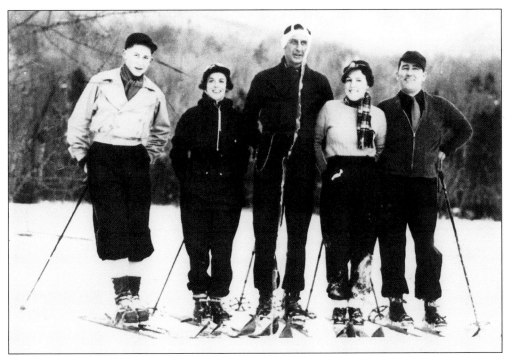

Roger Peabody (also shown in the group on previous page) poses with a happy class of learners: Roger, Martha Carpenter, Bob Sheehan, and Mrs. (we think) and Mr. Edward Labonte.

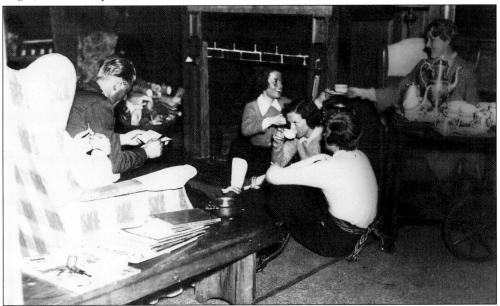

Apres ski at Peckett's was somewhat more decorous than it would become in most other ski inns. Here tea in the Pine Room is enjoyed by three young lady guests probably covertly admiring Sig Buchmayr, who reads a letter. Reflecting the history of the old farmhouse that formed the nucleus of the resort, this pine-paneled room with hooked rugs, New England antiques, and a welcoming open fire was a cozy spot indeed after a few hours on skis. Sig was an athlete and began every class with calisthenics, so sore muscles were not a rarity.

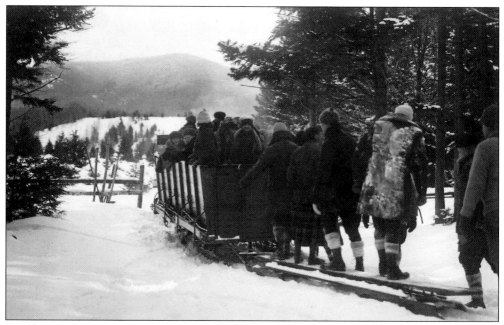

Another innovation among many at Peckett's was the popular al fresco lunch in such places as Coppermine Camp off the Easton Road. Even the trip there over the snow-covered terrain was to many a unique adventure. (PC)

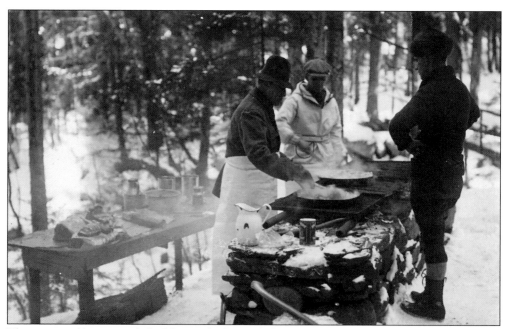

The aroma of hot soup, baked beans, barbecued chicken, and meats in the midst of a snowy world and the incomparable fresh air of the north woods was a rare and long-remembered experience. No appetite could long remain jaded. (PC)

With postcard pictures such as these showing the glories of winter, the enterprising Peckett family did much to change the popular attitude that the season was one to avoid as much as possible. The sunbathers lying on warm fur robes sometimes had a reflector of huge ice blocks behind them (below).

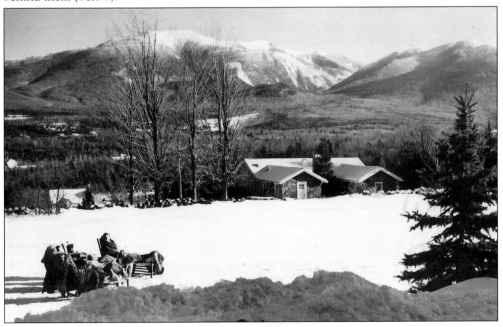

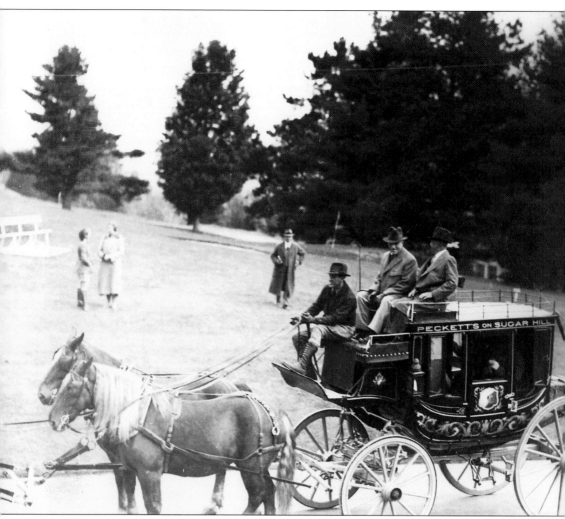

Symbolic of all Peckett's stood for in elegance and good taste was the magnificent Concord coach, a hallmark of the best of the early country inns. The beautifully decorated and maintained coach at Peckett's is seen here with Bert Reid managing the four-horse team. "Father" Peckett is at the right on the top seat with an unidentified guest.

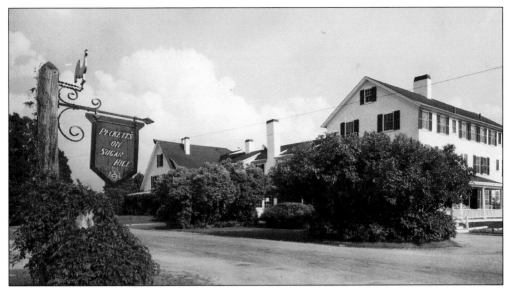

Peckett's was in many ways an Old World institution in an American setting. It catered to people of discriminating taste who returned year after year to the same familiar surroundings. Some of them purchased or built their own homes on the estate. Janet Gaynor stayed frequently at Sweetheart Cottage; Chief Justices Stone and Hughes were regular visitors; Lowell Thomas, an enthusiastic promoter of skiing, was often a guest; and Bette Davis purchased a home there and later built Butternut Lodge "out of three old barns."

But it was not to last. World War II and the changing times caused the grandson of the founder, Ross Coffin, to close the doors of the gracious old inn in 1967. The main building was later razed and the contents sold at auction. Most of the private homes have remained and others have been added, but it seems a strangely deserted place. All that remains of the main building is the stone foundation, the stairs leading to Erewhon, and the memory of tea dances and laughing couples under the trees.

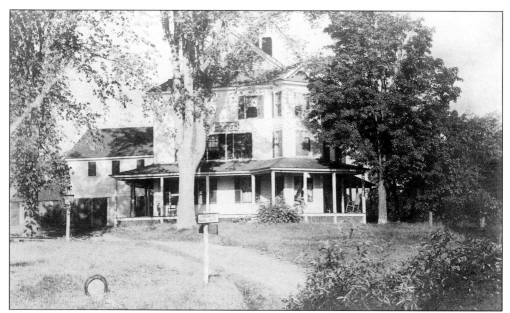

Representative of a different genre, one might say a more typically American kind of inn, is the building shown above. Now called the Homestead and still operated by the seventh generation of the first family, it was originally the home of Sugar Hill's pioneer settler, Moses Aldrich, and known in the early 1800s as the Elm Farm for its magnificent trees.

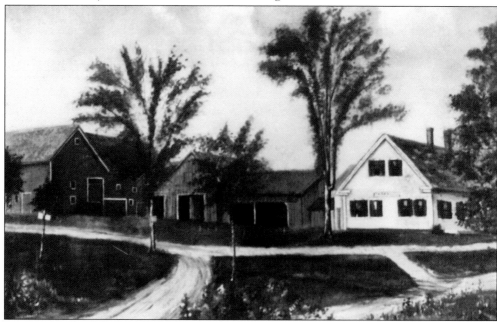

This oil painting hangs in the current Homestead Inn. The artist is unknown but was probably an itinerant painter. The painting is likely post-Civil War, but was made before 1892 when major reconstruction of the building took place. The large barn at the left is now the Sugar Hill Sampler, a combination gift shop/museum operated by a sixth-generation descendant of the original settler. Needless to say, the place is replete with artifacts from its long history as well as many purchasable items of unusual interest.

Although Homestead continued as an extensive farm operation, in 1882 the growing demand for tourist accommodations in the area prompted the family to take in a few summer boarders. The experiment proved successful, and by 1898 extensive remodeling was undertaken as seen below. (Here again, note the number of men poised on the topmost points that could be reached.)

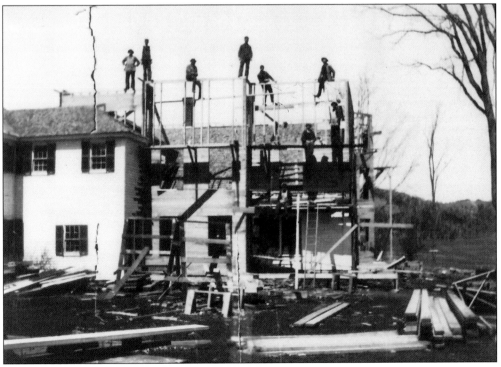

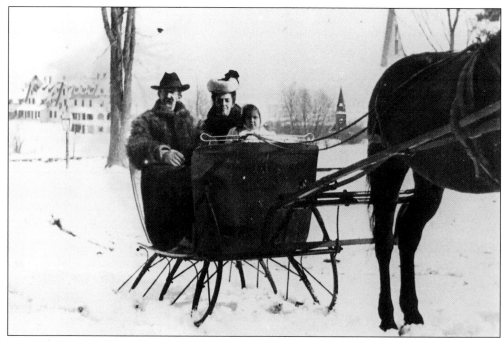

Mr. and Mrs. Daniel Teffts (she a daughter of the L. & S. Bowles whose names appear as proprietors on the register page below) became the owner-operators in the early part of the present century. Here they take a winter spin in the cutter with baby Esther, later to be Mrs. Enzo Serafini.

# The Homestead,

The management will not be responsible for money, jewelry or other valuables unless deposited at the office.

**L. & S. BOWLES, Proprietors.**
**Sugar Hill, N. H.**

Guests without baggage are required to pay in advance. Accommodations are first-class. Rates reasonable.

H. J. Schindler, Printer, Book Binder and Blank Book Manufacturer, Warren, Pa.

See instructions for forwarding mail in back of book.

| Time | Room | May    Name   1906. | Residence |
|------|------|------|-----------|
| May 21. | 9 | Miss Marie Taffe- | Wernigerode G/Harz. Deutschland |
|  | 9 | Mrs. Joseph D. Ibbotson N. (nebr. Sch.) | Clinton. N. York |
|  | 7 | Mr. Mrs. Amby White Simon | Hanover. N. H. |
| June 22 | 5 | A. P. Buswell | Barton Vt. |
| June 30. |  | Miss Marion Low Tucker | New York City. N. |
| June 30. | 5 | Miss Marguerite Haight | New York City. N. Y. |
| July 1 | 13 | Mr. E. Ellsworth. | New York City. |

Part of the hotel register page for May 1902 is shown here. This is not the oldest register still in the inn's possession, but was the only one available at the time of our visit. Of interest, the first visitor was from Germany.

By 1940 the Cannon Mountain Ski Area—with its first-in-the-country aerial tramway—was in full swing and more and more people were seeking winter accommodations. The Homestead at this time was being run by Enzo Serafini and his wife Esther Tefft, a direct descendant of Moses Aldrich. Active in the burgeoning ski world, Enzo found it natural to attract this group to the inn and Essie saw to it that they were warm and well fed.

Another example of the farm-turned-inn was the farmhouse dating from 1784 just south of Franconia Village on what is now Route 18 where it crosses Lafayette Brook. The painting above shows it as it might have looked in the early 1800s. For most of the nineteenth century it was a working farm under various owners, supplying dairy products, eggs, and vegetables to the big hotels including the nearby Profile House. It was first used as an inn toward the end of the century by one D.K. Priest, and known simply as Priest's House.

In 1929 a Boston hotel man by the name of Charles Lovett purchased the property, remodeled it, and established an all-year guest house that soon became popular with skiers as well as summer visitors. At right in the photograph above are Mr. and Mrs. Charles Lovett Sr. chatting with winter guests in their pleasant sitting room.

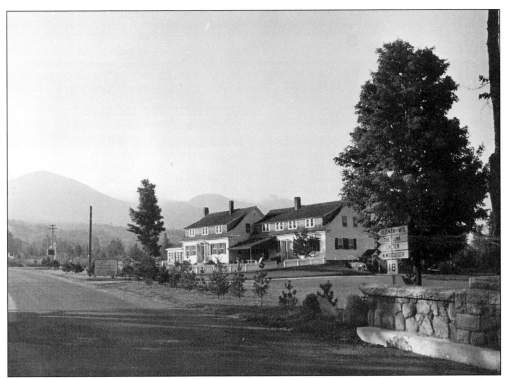

Seen here in 1932, Lovett's Inn looks much as is does today on the outside except for the addition of eleven cottages in back and to the left. When "Puppa" Lovett retired, his son Charles Jr. followed in the parental footsteps and proved himself a natural-born host much appreciated by his many guests and a decided asset to his adopted community. The inn remained in Lovett hands for more than sixty years and is now carried on in the very best of inn-keeping traditions. The inn, quite properly, is listed on the National Register of Historic Places.

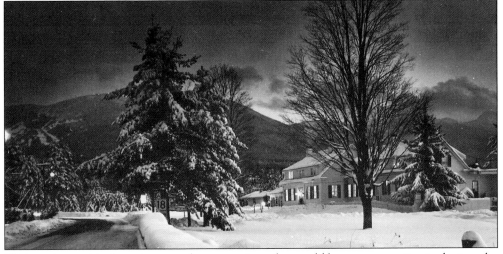

With a winter night lowering over the mountains, what could be more attractive to the traveler than the welcoming lights in the windows of a warm inn. We are indebted to Dorothy I. Crossley for this fine example of her professional work.

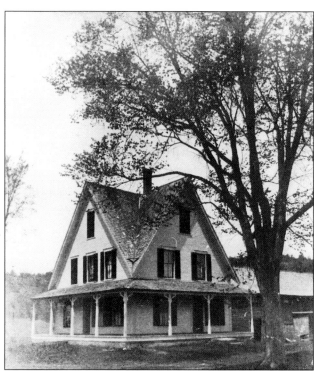

In the summer of 1938 a newly married young couple, Selden J. Hannah and Pauline A. Lee, found the farm they had been looking for just north of Franconia Village. It was the Temple Farm, the original house going back some 150 years, making it one of the earliest in the region. It was occupied and worked by Farmer Elmer Temple, who had then been there forty-five years and had many interesting stories to tell. According to him the distinctive, high gabled roof had been added in the 1860s.

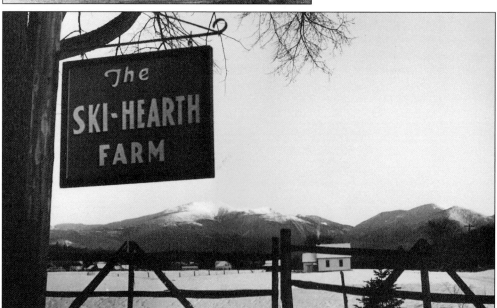

The Hannahs purchased the farm, Sel being assured by Temple that several of the previous owners had pretty high mortgages but always managed to pay them off! In the meantime Sel had accepted an offer from Roland Peabody, manager of the new Cannon Mountain Aerial Tramway, to design and supervise additional trail construction on the mountain. Not content with farming, a new home that needed a lot of work, and a challenging new job, the energetic young couple, both well-known in the ski world, decided to take in guests. So was launched The Ski Hearth Farm.

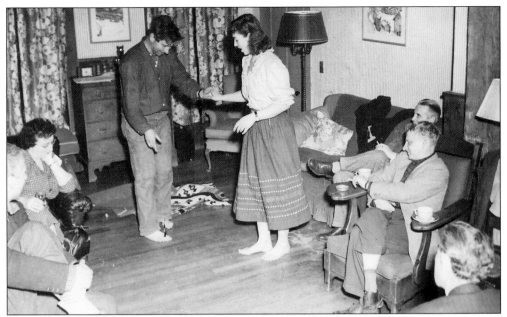

The atmosphere at Ski Hearth was relaxed and friendly. Most of the guests either knew one another or as skiers quickly settled down to an easy camaraderie. Here, the host and hostess give a barefoot dance demonstration.

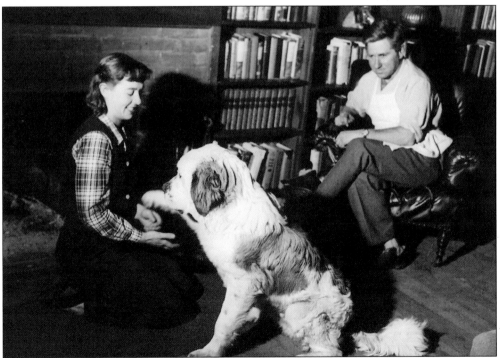

Life was very full for the young couple; four children came along very quickly and work was never-ending (note Sel's apron), but for the most part enjoyable because they were making their own lives the way they wanted them. And occasionally there was a moment for relaxed conversation with Spike.

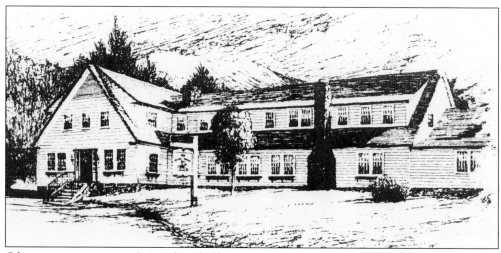

Of more recent vintage (it's only a half-century old) but still based on the tradition of the converted farmhouses, is the Horse and Hound in a quiet nook off Route 18 in Franconia at the base of Cannon Mountain. The first owner, Tally Ruxton, skier and World War II veteran, bought a c. 1830s farmhouse, cut timber from the property, and erected the substantial inn seen above in an artist's rendering.

A conversation piece in the large central lounge is an old autographed photograph of Joan Fontaine (shown above) that was given to Ruxton when Fontaine stayed at the inn during a visit with her friend Bette Davis.

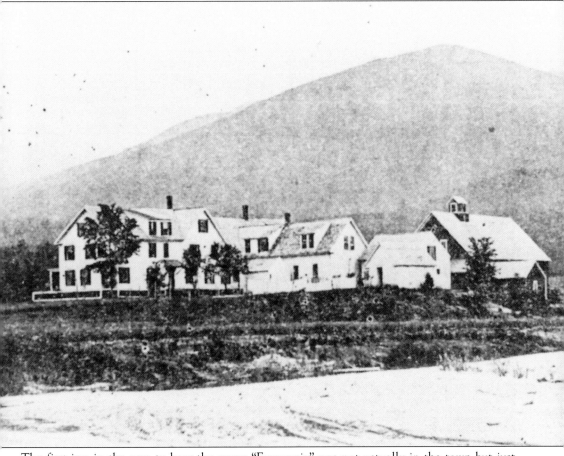

The first inn in the area to bear the name "Franconia" was not actually in the town but just over the line in what is now Sugar Hill. Originally Goodnow's House (sometimes spelled "Goodnough"), the name was changed when John W. Peckett joined with Mr. Goodnow in enlarging it (see p. 82).

What is now the Franconia Inn on the Easton Valley Road (Route 116) in the town of Franconia occupies the site of Zebedee Applebee's (wonderful name!) farmhouse built shortly after incorporation of the town in 1772. The building also served for a number of years to hold the town meeting. The year the Civil War ended, the farm became the property of Henry Spooner, who soon followed the growing pattern of taking in summer boarders as word spread of the wonders to be found in the White Mountains. Early in the 1900s, the property was acquired by Edward and Gladys McKenzie and became McKenzie's Hotel. The tremendous building was destroyed by fire on a frigid January night in 1934. The illustration above, a halftone from an old advertisement, shows the Spooner Farm before its acquisition by the McKenzies.

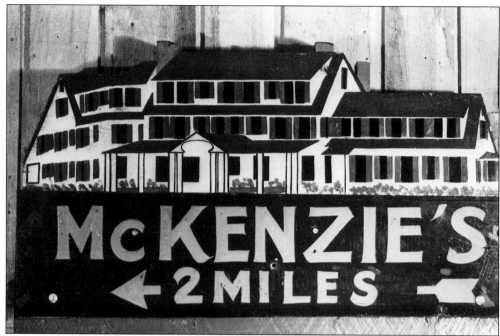

This old solid wood sign, made of 2.5-inch-thick planks, hangs in the lounge of the present-day Franconia Inn. Evidently a directional sign, it escaped the fire and gives us a good idea of the appearance of the old hotel shortly before its end. The resemblance to the modern inn (below) is quite remarkable.

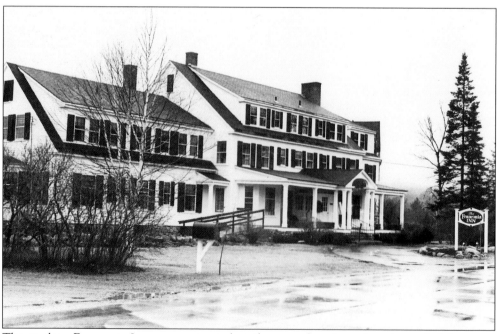

The modern Franconia Inn—reconstructed at the same location—is today a thriving year-round hostel operated by the Morris family.

*Five*

# Close Ups

Seated on the porch of the Cooley Farm in Sugar Hill are Alonzo and Emmeline Cooley, photographed by their pastor and neighbor, the Reverend Samuel S. Nickerson. Alonzo is enjoying a no doubt well-earned rest; Emmeline (surely he called her Emmy) is coming as close to resting as was generally possible for that time and place. At least she could sit down to the spinning wheel, in contrast to the "great" or "wool" wheel, which was also called a "walking wheel" for good reason. (SSN)

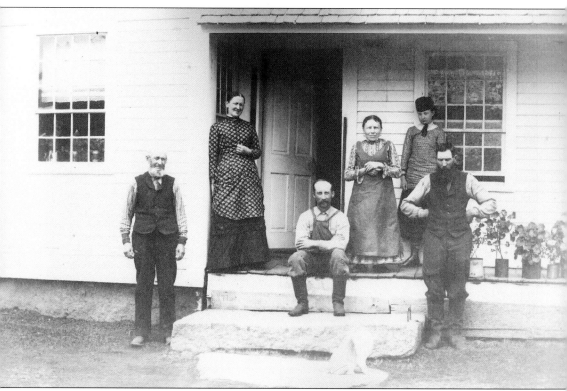

The Aldrich and Bowles families might almost be said to have settled the Sugar Hill region of Lisbon. They certainly began it. William Aldrich came here with his family in 1780. His son Moses settled on land that would become first Elm Farm and finally (still) The Homestead. Jonathan Bowles (originally Bolles) came about 1790, married the sister of Moses' wife, and from then on only a confirmed genealogist would attempt to analyze the result. At any rate the families obeyed the Biblical injunction to "be fruitful and multiply." Above is the family of one of the many descendants, Alpheus Bowles, probably about 1875 or earlier.

The well-dressed, healthy-looking children of Erwin and Vienna Bowles are seen perhaps about 1880. From left to right are Jay, Elgie, Clara, and Ernest.

The four children above, now quite grown up, appear with their parents. From left to right are Vienna and Erwin, Ernest, Clara, Elgie, and Jay. Seated is the perfect picture of a grandmother, another Vienna Bowles, shown again on the next page

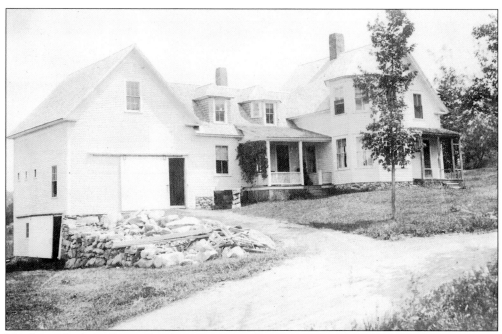

The home built by Ernest Bowles on Sugar Hill Street still stands there, but Ernest had the unfortunate distinction of being killed by lightning in August 1917.

Mrs. Leonard Bowles, referred to on the back of this well-preserved cabinet photograph as "Great Grandmother Bowles" and also as "Aunt Vienna," serves beautifully to remind us what these tiny (probably about 5 feet, 2 inches tall) but incredibly tough (if one may use so indelicate a word in such a connection) ladies accomplished in bringing civilization to an undeveloped land. (CLP)

Of the many families that have come, stayed, prospered, and served this region, an outstanding example is that of the descendants of Joseph Erwin Herbert, who is pictured here with a group of his progeny. Born in 1844 in Piermont, he married Adelaide Pettengill and shortly after that the couple moved to Franconia where they remained for the rest of his seventy-six years, raising a flourishing family. Descendants are still numerous here and in other parts of the country. Joseph and Adelaide had seven children, two of whom died in infancy. The other five are included in this group: Joseph Jr. is at the far left; Flora (wearing a large bow tie) is seen with her husband, Frank Sanborn; Ernest stands in front of the doorway; Willis is next to him; the eldest son Charles Henry (usually known by his second name) is at the right holding his niece. Mr. and Mrs. Herbert are of course seated. We regret that space does not permit identification of the rest of the group.

Joseph E. Herbert drove the mail stage from Franconia to Littleton for seven years. His grandson Willis, shown here with him, was postmaster in Franconia for twenty years (appointed by FDR) and a memorial sundial to him stands in front of today's post office.

Here we have the family of the grandparents of the donor of these photographs, George Herbert of Littleton. Charles Henry Herbert and his wife Eliza Bean are seated; the children, from left to right, are Huyler, Clayton E. (father of the donor), Edith, and Bertram.

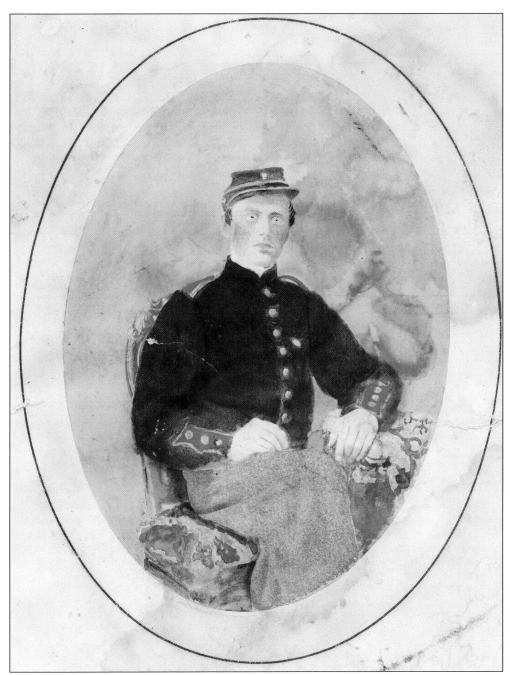

A watercolor sketch by unknown artist shows us Lorenzo Bean, the father of Eliza (shown on the previous page). Bean was captured and confined at the infamous Libby Prison in Nashville, from which he escaped with a bullet wound in his leg. He is buried in the Bean family lot in Elmwood Cemetery.

Amy Morse Dexter was a teacher at Dow Academy in the 1920s. Her second marriage, after the death of her first husband, was to Clayton E. Herbert and they would become the parents of Clayton, George, and Joseph, currently well-known residents of Littleton.

Amy and Clayton, home from their honeymoon, pose with their wonderful touring car with vertical windscreen and collapsible roof. Seen behind them is the famous spring on Coal Hill that was the town water supply for some years.

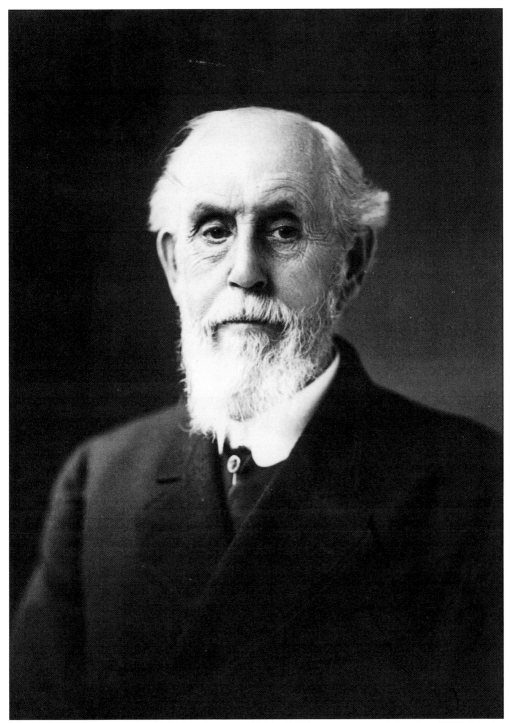

The Reverend Samuel Stickney Nickerson (1835–1930) was pastor of the Free Will Baptist Church in Sugar Hill for nearly forty years. A minister devoted to his community, he was also an accomplished photographer who has left us a wonderful record of the life of that time and place. One of his daughters, Bessie, followed him into the profession of photography.

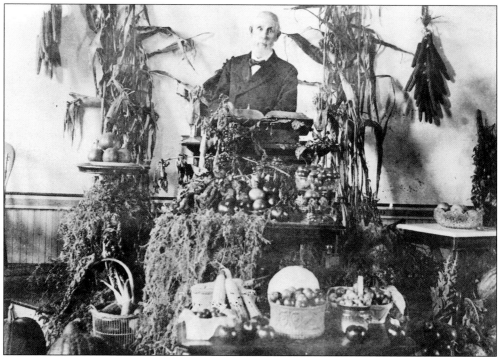

The Reverend Mr. Nickerson is seen in his Baptist church pulpit on Harvest Sunday, September 27, 1908.

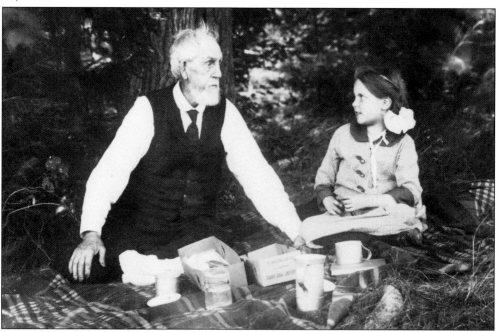

In a more relaxed moment, the reverend gentleman enjoys a picnic with granddaughter Ruth Bowles. Ruth and her sister Rebecca were largely responsible for preserving the wonderful collection of Bowles family photographs and presenting them to the Sugar Hill Historical Museum.

Seth F. Hoskins is shown here with his wife Martha Stevens on the grounds of the Sunset Hill House, which he built in 1880. Together with his son Carl he operated and expanded the huge complex to a capacity of some 300 guests. Owned and operated in more recent years by Warren R. Swift, it was one of the largest and longest-lasting of the grand hotels, closing its doors finally in 1973.

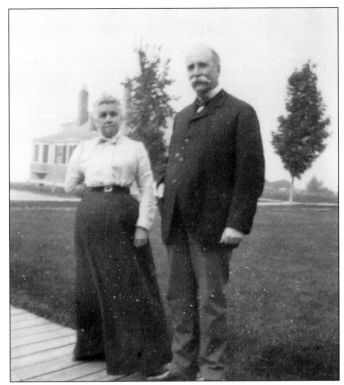

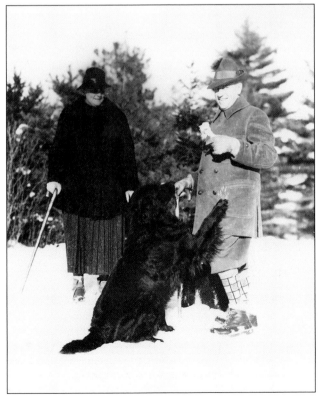

Mr. and Mrs. Robert Plympton Peckett (Katherine Billings) were often referred to as "Father and Mother" Peckett, although it was Robert's father John Wesley Peckett of New York who first became involved in hotel construction and operation in the area. Duke, a very photogenic dog, posed frequently for guests.

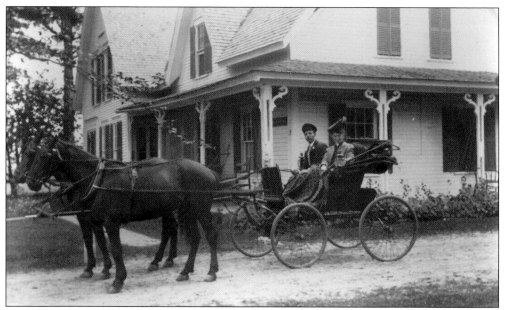

With the larger town of Littleton and its hospital and numerous physicians nearby, Franconia was fortunate to have the local services of Dr. Hiram Johnson. A "horse and buggy" doctor in his early years in practice, he no doubt graduated to a car after World War I, in which he attained the rank of major. Following the death of his first wife (pictured here), he married Dr. Sarah Elizabeth Coppinger and the two established a small clinic in the building shown.

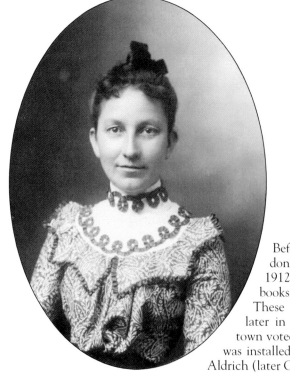

Before Colonel Greenleaf's generous donation of the fine Greenleaf Library in 1912, the town had a growing collection of books, many donated by summer residents. These were housed first in Burt's Store and later in a separate building when in 1892 the town voted to create a free library. A library board was installed and the young lady pictured, Miss Eva Aldrich (later Cummings), became assistant librarian.

Sometime around 1900, Daniel Tefft and his magnificent team of oxen perform some of the many winter chores to be done on the Homestead Farm.

Young Miss Esther Tefft, better known to us in later years as Essie Serafini, ushers in the automotive age c. 1913.

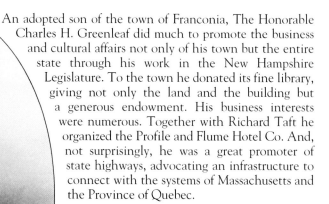

An adopted son of the town of Franconia, The Honorable Charles H. Greenleaf did much to promote the business and cultural affairs not only of his town but the entire state through his work in the New Hampshire Legislature. To the town he donated its fine library, giving not only the land and the building but a generous endowment. His business interests were numerous. Together with Richard Taft he organized the Profile and Flume Hotel Co. And, not surprisingly, he was a great promoter of state highways, advocating an infrastructure to connect with the systems of Massachusetts and the Province of Quebec.

Among the many innkeepers who played important roles in this area was Karl Abbott, shown here with two hunting friends. Born in the Uplands Hotel in neighboring Bethlehem, which was at that time owned and operated by his parents, Karl entered the hotel business at age twenty-one, joining with his father to form the firm of Frank H. Abbot & Son. The company took over and greatly expanded the Forest Hills Hotel in Franconia and in 1920 purchased the Profile & Flume Hotel Co.

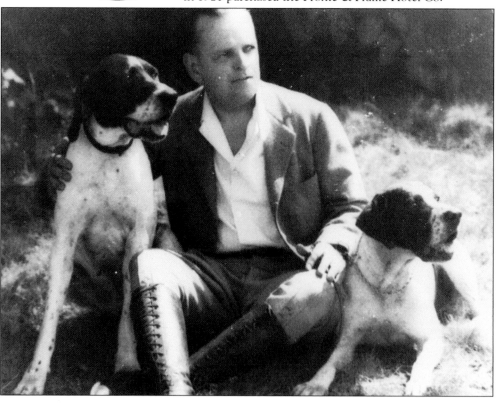

A commemorative bronze coin marked the dedication of the first aerial passenger tramway in North America on Cannon Mountain in Franconia Notch in June 1938.

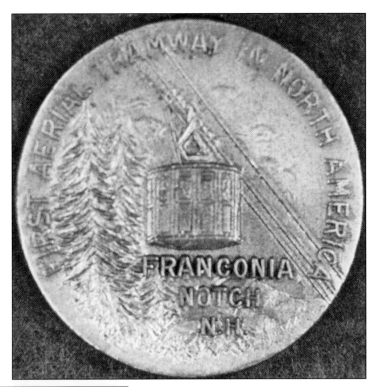

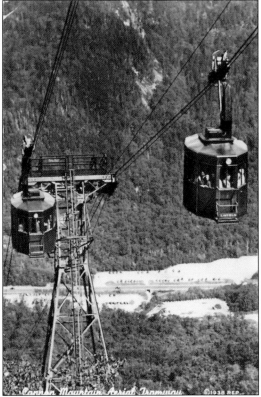

A postcard mailed from a special postal sub-station "At Summit of Cannon Mt., Franconia Notch, N.H." shows the first pair of cars. They were equipped with headlights and metal ski racks on either end. There's a story, perhaps apocryphal, that the crew (attendants) sawed off the racks to avoid lifting hundreds of pairs of skis every day; from that time on each skier has carried his own skis, vertically, of course, into the car with him. The cars were named Lafayette and Lincoln for the nearby mountains.

115

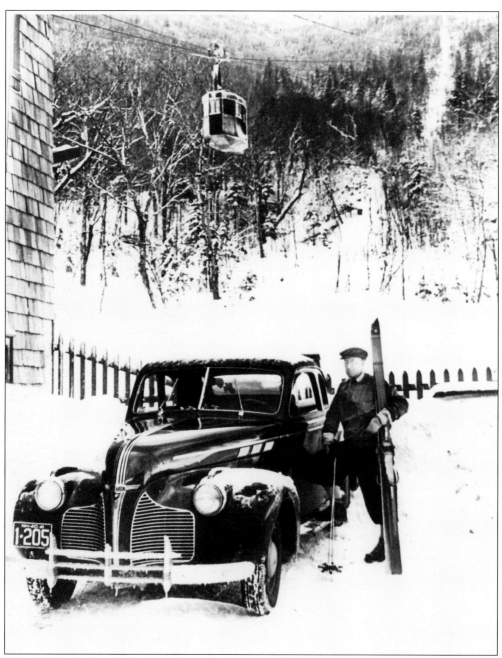

Roland E. Peabody, a lifelong resident of Franconia and a devotee and promoter of skiing from its inception in this region, was not only the first manager of the aerial tramway but played a major role in the selection of Cannon Mountain as its site. There were of course other contenders for the honor. He was also one of the organizers and first president of the venerable Franconia Ski Club, which has continued over these many years to promote the sport, especially in the indoctrination of youngsters. Largely due to these efforts, ski instruction is now available to every public school child in the region. The well-loved Roland Peabody remained manager of the tram from 1937 until his death in 1950.

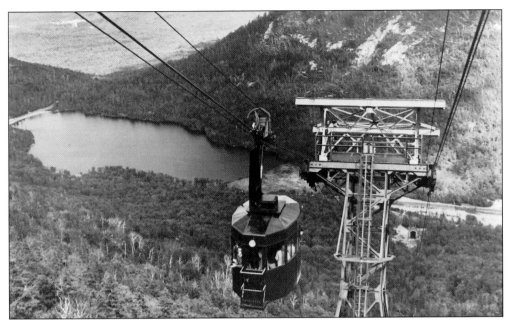

This view of the Lafayette (the name can be made out at the bottom of the ski rack) was presumably taken from the Lincoln, the two cars having just passed at the mid-tower. They work on a counterbalance system, the pull of the descending car making it considerably easier to haul up the other. Echo Lake is handsomely placid in the summer sun, and the base of Eagle Cliff is seen behind the tower. Just to the right of the tower on the near side of the highway may be seen the toy-like base station.

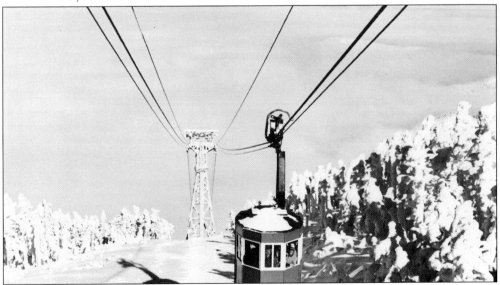

Cannon Mountain in winter is a veritable fairyland, the frost feathers building into the wind making the trees as white as sugar candy. One of the first set of cars was damaged in a high wind. The second set was painted red with white trim, as some thought the dark forest green too dull. This car is seen at the flattish area a little way above the mid-tower. Although the tram was built primarily for skiers, the ride is very popular during the summer-fall operating period, especially in foliage season. The beloved old tram was replaced in 1980.

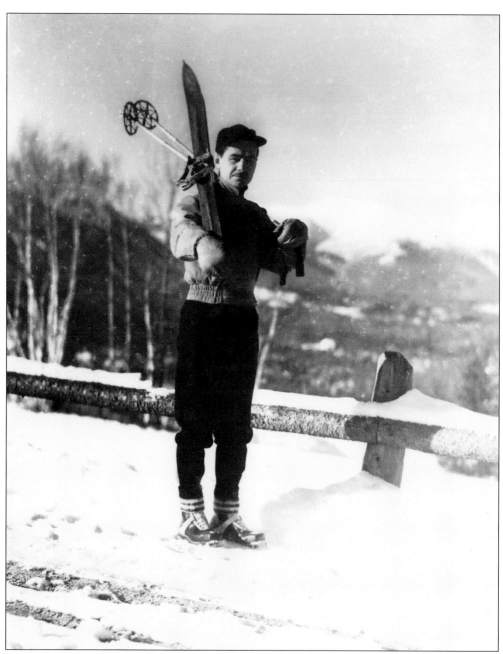

A world traveler because of his work as the foremost American news commentator of the early and mid-1900s, Lowell Thomas loved skiing and stayed at Peckett's when the opportunity offered. He is seen here modeling proper ski attire of the 1940s: baggy pants (an old-time skier once remarked, "Once my pants were baggy and my face was smoose; now my pants are smoose and my face baggy"), socks worn outside the pants, a short poplin jacket, ridge-top hickory skis with beartrap bindings, and large-basket, bamboo poles. The cap was a classic style with earflaps and strings to tie under your chin when the going got tough.

Thomas did much to popularize skiing, frequently arranging his 7 pm news broadcast from ski resorts around the country, including Cannon Mountain.

Sarah Nelson Welch lived all her life and most of the twentieth century in the town of Franconia. Always interested in the history of the area, she gave frequent talks on the subject and ended by publishing in her later years *A History of Franconia New Hampshire*, the most complete such record to date. True to this interest to the end, she left her home and the many artifacts she had acquired to the town to be used for historic preservation purposes. As of this writing it appears quite certain that this bequest will give rise to a museum of Franconia history.

At right we have a young Sarah in 1919, and below a sensitive study in her later years, when she was still very much involved with life. She died on February 5, 1989.

The entrepreneurial skills and awareness of the North Country were much stimulated by the coming of tourism and the grand hotels. Not only did farmers of the region benefit from the sale of fresh vegetables, eggs, and dairy products, but flowers also seemed to be in constant demand and here the small fry played its role too. Above, mother and daughters make rosettes, perhaps for coach decoration; below, what hotel guest could resist these enterprising young businessmen dressed to the nines?

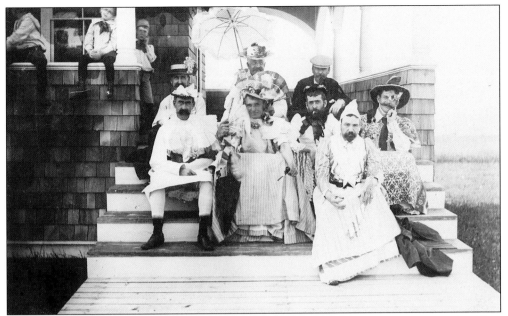

Before television people were in the habit of providing much of their own entertainment. Just what these male guests at Sunset Hill House are up to here is not known to us, but the children seem to be at least moderately entertained.

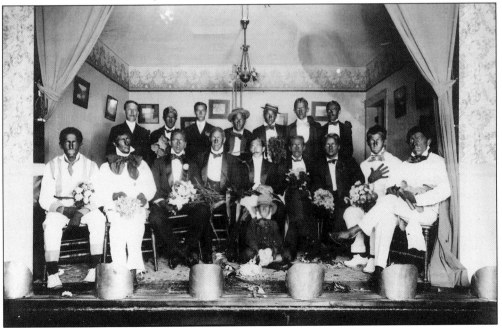

One very popular form of entertainment that later came under criticism was the black-face minstrel show (this one at Sunset Hill). Songs, from the author's memory, were of the variety of: "Rufus Rastus Johnson Brown/What you gonna do when the rent comes round?/You know, I know, rent means dough/Landlord's gonna throw us right out in the snow", etc. A standard joke was: "Who was that lady I saw you with last night?" Indignant reply: "That wasn't no lady. That was my wife!"

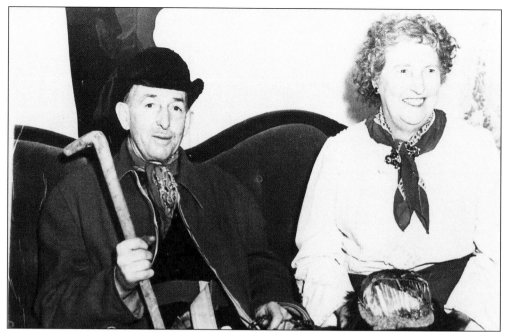

During the depression years of the 1930s–40s, there arose the immensely popular "Poverty Party" (a form of entertainment, not a political party). People by and large could not afford to go out for their amusement, so one of the things to do was to dress up in old, ragged clothes (very available) and get together at someone's house to dance to the radio or victrola. The senior Lovetts ("Puppa and Mumma") set a cheerful example for their guests at the inn by Lafayette Brook.

Following military service in World War II (in the air transport command stationed in India for much of the war), Charles Lovett, Jr. found it entirely natural to step into his father's shoes. His natural Irish charm and genuine interest in his fellow man made him the perfect host and Lovett's Inn continued to flourish under his management.

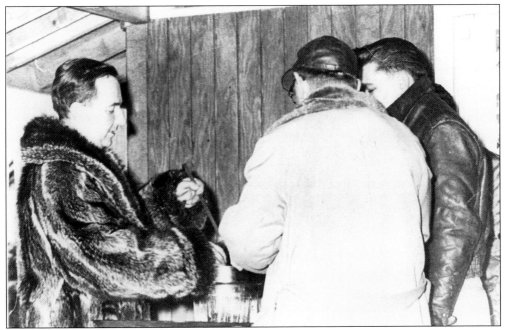

Charlie Lovett's willingness to pitch in and work for any worthwhile community project is shown here as he serves hot punch to racing car drivers who were staging a race on frozen Echo Lake. The purpose? To raise money for the Franconia Ski Club to purchase ski equipment for the group's youth training program.

This photo of an older Charles speaks the truth of Franklin D. Roosevelt's reply to the statement that an individual could not help the way he looked: "Any man over the age of forty is at least partially responsible for the face he wears," said FDR. Character shows.

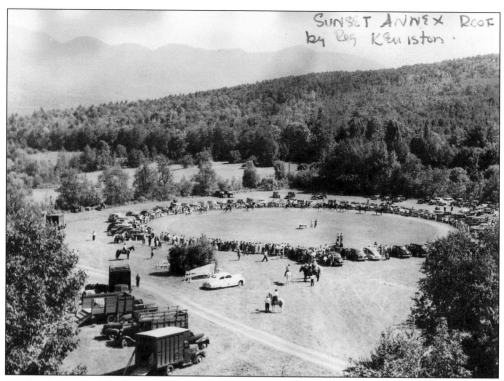

*SUNSET ANNEX ROOF by Reg Keniston.*

Following World War II things took a decided upturn for the average U.S. citizen, at least in most parts of the country, including New England. A sign of the more affluent times was the very popular Sugar Hill Horse Show held on the grounds adjacent to the Homestead Inn.

A prize-winning entry is shown here: Barbara, the daughter of Essie and Enzo Serafini (owner-operators of the Homestead), and her mount.

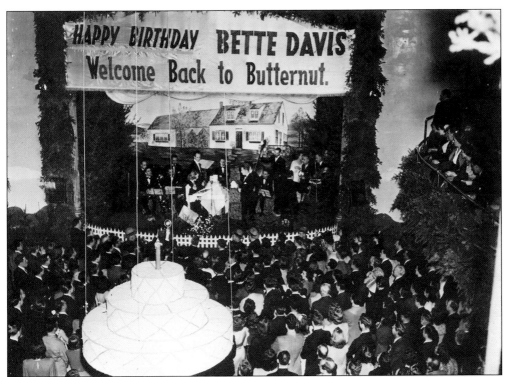

Surely one of the most widely-known personalities to grace Peckett's was Bette Davis. She came first as a guest, bought a home on the hill for her mother, and later built another for herself named Butternut, which is pictured in the stage backdrop above. The occasion was a gala one—her birthday and the world premiere of her film *The Great Lie* in Littleton. The crowd at the grand ball in the Opera House listens with rapt attention while Bette reads some birthday messages and gets ready to cut the huge cake. The date: April 5, 1941.

In a rare moment of being just plain Bette, the glamorous star relaxes in her Sugar Hill home after skiing. (Yes, she really did.)

The Hannah family has been mentioned in connection with Ski Hearth Farm (p. 96), but here we offer a closer look at some of the members. The photograph of Sel is selected not for its quality (it's a reproduction from a halftone from the rotogravure section of the old *Boston Herald*) but because it typifies his exuberance, the zest he brought to everything he did.

In the world of skiing he tackled everything: a four-way competitor (entering slalom, downhill, X-C, and jumping competitions), he won countless honors and was an obvious choice for the U.S. Olympic Team of 1940, but World War II interfered.

As a farmer, an early and permanent passion, he was astonishingly successful. Specializing in potatoes, he became one of the largest producers in the region but that did not prevent his other crops from being in great demand. "Sel Hannah's corn" became a byword even among people who probably thought it was a variety, like Golden Bantam.

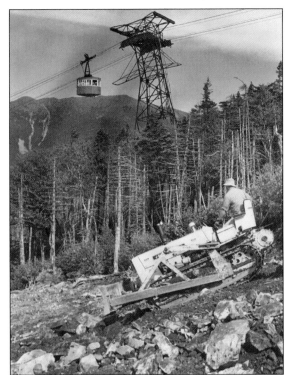

And as if all this were not enough to occupy anyone fully, Sel launched a ski area design company and was not above operating the bulldozer himself. Not wishing to limit himself too much, he designed his business card to read: "SEL HANNAH—Consultant/Ski Areas and Allied Endeavors." Sel is seen here with Sherman Adams as the two discuss details of the development of Sherm's Loon Mountain ski area.

Of all the thousands of photographs it has been the author's privilege to examine for this work, the one presented here is surely the most touching. Paulie Hannah, herself a sculptress of considerable ability before being stricken with polio in 1949, is shown with her art teacher and sculptor Simon Moselsio and his completed model for the bronze memorial plaque of Roland Peabody that now hangs in the base station of the Cannon Mountain Aerial Tramway. Their mutual pleasure in the occasion is obvious.

Joannie, the first of four children (two boys, two girls) born to Paulie and Sel Hannah, takes a good look at the world before starting off on her route to become Junior USEASA champion in 1957; National Junior DH Champion 1956 and '57; US Olympic Team member 1960 and '64; and bronze-medal winner in the 1962 FIS. Joan inherited her mother's artistic talent, studied under the same teacher, and finds time in the midst of her many responsibilities to create artistic pottery in her studio on the grounds of Ski Hearth Farm. (Photo by John Jay)